SCULPTURE

TECHNIQUES IN CLAY · WAX · SLATE

SCULP

CHILTON BOOK COMPANY

RADNOR, PENNSYLVANIA

TURE

TECHNIQUES IN CLAY · WAX · SLATE

By

FRANK ELISCU

PHOTOGRAPHS OF PROCESSES BY CONRAD BROWN

Published in Radnor, Pennsylvania, by Chilton Book Company,
and simultaneously in Ontario, Canada, by Thomas Nelson & Sons, Ltd.

ISBN 0–8019–0369–6

LIBRARY OF CONGRESS CATALOG CARD NUMBER 59–7275

MANUFACTURED IN THE UNITED STATES OF AMERICA

TO MY WIFE

ACKNOWLEDGMENTS

My heartfelt thanks to Erwin S. Wolfson whose interest in art made the Naiad possible; to Harrison Tweed who had my first wax cast into bronze more years ago than either of us can remember; and to the countless other wonderful people whose unflagging faith and interest in my work has been a real inspiration. . . .

And last but not least, my thanks to a most understanding family who believes in art as a career.

FRANK ELISCU

CONTENTS

Acknowledgments 6

Foreword 11
 Good Design: Is It Taste? 12

Clay 13
 Snake 14
 Snail 16
 Elephant 18
 Mouse 19
 Duck 20
 Bear 21
 Self-Supporting Wet-Clay Modeling 22
 The Armature 22
 Prophet 24
 Heads 32
 Plastilene 38
 Tools for Modeling 38
 How to Take Care of Wet Modeling Clay 39
 Torso 39
 The Transient Media 41
 Redesigning the Human Figure 45

Wax 63
 Herons 66
 Fawn 69
 Nymph 75
 Composition 81

Casting 117
 The Bronze Foundry 121

Cast Jewelry 123
Spoon Birds 123
Centrifugal Casting 125

Slate 131
Pachyderm 134
The Tools for Slate 136
Nude 138

Pebble Sculpture 159
Pebbles 161

Genesis of a Statue 169

Postscript 180

Appendix 181
Sculptors' Tools 182
Sculptors' Suppliers 184

Index 189

SCULPTURE

TECHNIQUES IN CLAY · WAX · SLATE

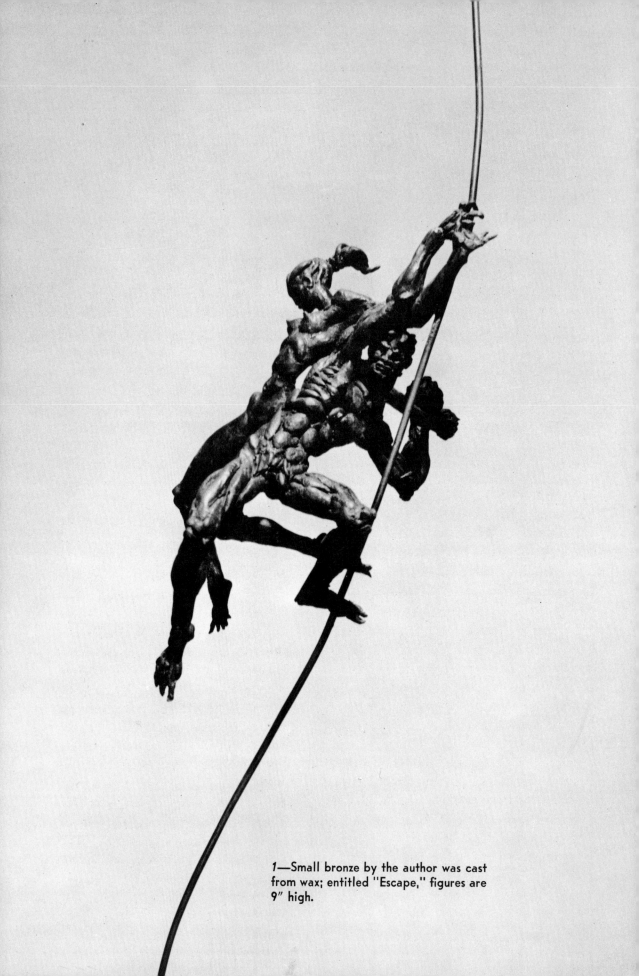

1—Small bronze by the author was cast from wax; entitled "Escape," figures are 9" high.

By doing sculpture you will discover that the whole world is sculpture. Missing from the lives of so many people today are the deeply felt esthetic experience and the humanization of life through such an experience that producing a work of art can provide. It is a fantastic thing—possibly credible only among those to whom it has happened—how a person's total relationship to his environment is changed through the continued act of creating art. Suddenly one day the Sunday painter is astonished at the magnificent lavenders and blues that appear across the faces of dingy city buildings at twilight. Similarly, the Sunday sculptor becomes conscious of his new "eye" for form: a pebble on the beach becomes a shape to be judged with sureness—it is either beautiful or it is not, and the eye trained to three-dimensional beauty will know immediately. A rose is not a rose any longer but one of the most wondrous exfoliating forms in nature. A tree is more than a tree, a shiny bug is not just another insect—but perhaps the greatest ulterior gratification that becoming a sculptor provides is a new appreciation of the planes of beauty in the face of your fellow man.

In spite of a strong prevailing urge in our time for people to express ideas beyond the limits of the spoken word, pretty much neglected by the ordinary person is the area of three-dimensional expression. In actuality, this is one of our oldest means of communication. Except for a few cave drawings by prehistoric man, all we know of our ancestors comes down to us in three dimensions. Records of ancient civilizations, of what people thought and what they did, are preserved in the pottery, toys, replicas of gods, ornaments, and utensils they fashioned and which archaeologists have unearthed.

Sculpture, then, is a medium of timelessness with a venerable tradition. It is too bad that it has come to be considered a medium for experts only. In spite of the *mystique* grown up around sculpture that makes the layman shy away from it, to demonstrate that sculpture is really not so forbidding is the purpose of this book. It shows how to do three basically simple techniques with which people trying sculpture for the first time can start expressing themselves immediately. For, though sculpture is not easy, it is not as hard as it is thought to be.

It is a short step from beginner to competent amateur in the arts, but a tremendous step from there to anything approaching professionalism. It is a long step indeed to true professionalism (one almost nobody takes), where the artist with something to say has the technique to express it with fluidity and ease.

If you are an artist nearing semi-professionalism yet groping for a new means of expression, this book gives you the simple ABC's to a language of three-dimensional self-expression in contrasting mediums. What you say with it, of course, is up to you.

If you are deeply involved in sculpture and find yourself spending a great deal of time at it, you will discover that switching from one medium to another provides a great release. Try all three mediums presented here—

clay, wax, and slate. Each has its own disciplines and freedoms.

The total concentration that modeling in clay or wax calls for provides an enjoyable hiatus from the cares and complications of the day. If you make a figurine of a dancer or an athlete in violent action, you may find yourself emptying all your tensions into the figurine as it evolves.

A creative outlet for the person growing older becomes more than fun —it can be a vital necessity. Creativity gives life a direction, as any musician, artist, or writer will agree. To creative elderly people, age means nothing; you never find senility among them. As a matter of record, for many artists the most productive years have come toward the end of life: both Titian and Michelangelo were still turning out masterpieces in their eighties; Matisse produced his magnificent church at Vence in his eighties, propped up in bed handing cutout pieces of colored paper to an assistant to pin up on the wall of his room; sculptor Carl Milles worked right up to the age of eighty; and Claude Monet did his incomparable water-lily series as an octogenarian. These men were not sitting in the park playing checkers. Creativity kept them active, and the totality of their experience only increased their facility as they got older.

GOOD DESIGN: IS IT TASTE?

There are certain fundamental truths that cut through all art forms —basic design tenets, many of them subconscious—that our age lives by. But design itself, the most important aspect of art, is at the same time the most difficult thing about art. The trouble is, design often gets confused with taste. Standards of taste and ideals of beauty have changed continuously over the ages, but the tenets of good design remain firm and are the foundations of all art.

It is such a tenuous thing, design, that it almost seems impertinent to analyze it or even discuss it in a book like this—if words ever *can* describe it. Instead we will endeavor to show visually what we consider good design —the only way it ever can be communicated adequately—through photographs of sculpture that we believe fulfill the unchanging principles of balance and movement, form and line, rhythm and flow, that make up the philosophy we call design.

The person who works at sculpture finds himself taking a firm new stand on the subject of design, knowing that he likes this vase, does not like that chair, and knowing immediately without any nagging doubts. Being sure of what you really like is an exciting manifestation of the sculptor's eye, providing for some people a brand-new air of self-assurance.

Not that doing sculpture is going to give you automatically a built-in sense of good design; what it seems to do is provide a climate for the development of an appreciation of good design, and, especially for young people, that is enough. The rest will follow.

What you will gain is the realization that everything in three dimensions surrounding you that the hand of man has touched, functional or decorative or fine art, originated as a sculptural ideal in someone's mind. And it is this that is important.

CLAY

SNAKE

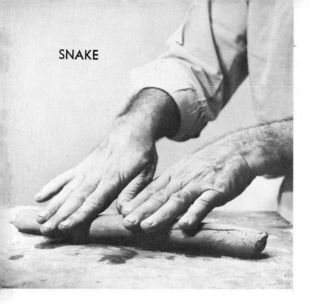

2—Roll out the clay on a level surface;

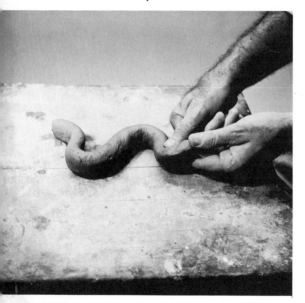

3—bend the coil into form of a snake.

4—Now lift up the form . . .

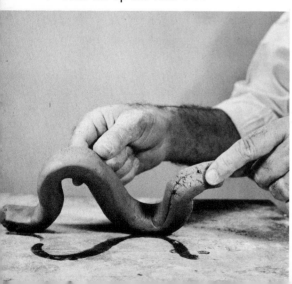

There is nothing more mysterious about the sculptor making statues than a child making mud pies—for the very clay you probably played with in kindergarten is the identical substance most used by the great masters of sculpture. Clay is a form of earth. Readily available everywhere, it is literally dirt cheap.

Sculptors actually use clay in two forms, either mixed with water (simply called "clay") or mixed with oil (generally known as "plastilene" or "plasticine").

Where do you get clay? Potters the world over dig it out of the ground themselves, wash it in a tub or a hole in the ground, put it soaking wet through a screen to remove the impurities, and use it when it has dried to its most plastic consistency. This is too much trouble for most people. You can buy clay at your local art store; people with initiative go to brickyards for it when they cannot find it anywhere else.

Clay, like mud, is made softer by adding water, and harder when water is taken out of it. When clay is completely dried out and brittle, water can still be added to it to make it soft again. With enough water added, clay turns to a creamy consistency called "slip" by potters or sculptors who pour it into molds. Clay can be carved when it is almost leather-hard. Watch out for one thing—clay shrinks an imperceptible amount as it dries, enough so that if you put anything inside a solid clay form, like a stick to hold up a statue, you have to figure on the shrinkage pulling the clay away from the stick. Cracks may form that could ruin your work.

14

If the clay you are using is to be fired, you must be sure there are no trapped air bubbles inside it. Air expands, of course, when it is heated. Result: the clay explodes in the kiln, and, in blowing up, may very well damage other pieces being fired with it. The best way to get rid of air bubbles in your clay is by "wedging" it, a business of thoroughly kneading the clay exactly like bread dough, slicing it in half with a wire or string once in a while to see if you still find any bubbles.

"Sculpturing" really means starting with a mass like stone or wood and cutting away to reach the desired form. The word "modeling," on the other hand, means starting with a small amount of plastic substance and building up piece by piece. In clay modeling some people add the clay in little pellets, some in coils, others in oblong rolls—haphazard building by chunks is seldom successful.

You should be aware that clay is composed of myriad tiny disks. By compression, these disks are made to lie face to face. A structure made by compressing the clay into place, therefore, is a strong one, while one in which a mass of clay has been drawn out without compression into a form is a weak structure. Unless you press the clay into the shape you are seeking, you will have much trouble making it hold its shape. The best way is to start with a relatively small amount of clay and add on to it, gently but firmly pressing each added piece into place.

A kiln is nothing more than a large oven that can be heated slowly to a high temperature—2,000 degrees or

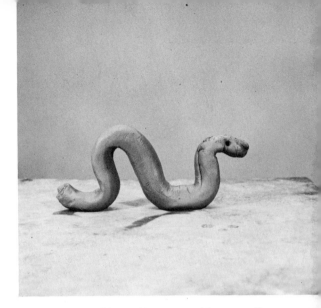

5—and by poking eyes with a pencil,

Though undoubtedly this looks very fundamental to you—the sort of thing a child might do—if you look at the pictures farther on through this section, you will see that the level of expression in the examples shown gradually rises, while the basic approach to clay remains the same: direct, quick, and bold. Whatever you want to say should be expressed in its simplest terms—in a word, a sketch.

6—it becomes a friendly worm.

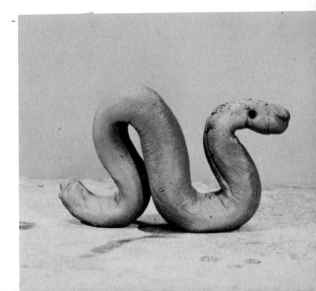

SNAIL

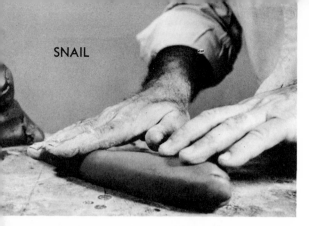

7—Roll out an elongated cigar shape.

8—Simply bend up the smaller end . . .

9—and roll it into a snail-shaped coil.

10—Stub an indentation with your thumb.

11—Press on a small rolled piece for

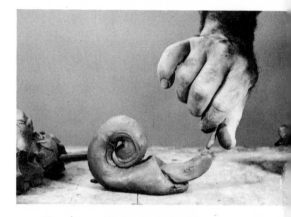

12—the snail's body and add his antennae.

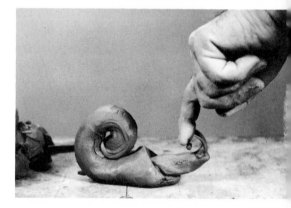

13—He only needs a couple of little balls

14—for eyes, and your snail comes alive!

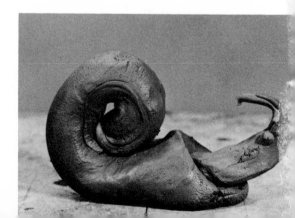

more. Primitive people fired their clay by putting their work right in the fire and keeping it burning for days. This is a simple way of producing ceramics, but such low-fired pottery is quite breakable.

Today we usually use gas-fired or electrically fired kilns, the cost of which varies from under fifty up to hundreds of dollars for a large kiln capable of temperatures that can vitrify clay into stoneware or porcelain.

Clay sculpture ought to be fired to temperatures of at least 1,600 degrees, and the higher the heat of the kiln above 1,600, the harder the finished work will be, up to the point where the clay actually melts and collapses.

The study of firing and glazing is a whole complicated science in its own right, and there is no point in going into it here, since our primary interest is not technical but rather the creative use of clay as a medium of expression. In fact, many people have had success firing their work at brickworks. The best bet in such a case is to buy clay directly from the brickworks itself.

The sculptor working in clay today owes a considerable debt to the potters of the past.

Clay was the only malleable material available to primitive man for making containers. His first pots for carrying water were undoubtedly chunks of clay scooped from the ground and left in the sun to dry after they had been pressed into some sort of rude bowl. Later, he probably formed clay over round stones to get a deeper vessel, and we have evidence that early man also made pottery by forming the clay over baskets woven from rushes and reeds. Eventually, he learned to build forms, starting with a flattened disk of clay and constructing walls around its perimeter out of small chunks of wet clay. Still later came coils to replace the chunks—and millennia later, following the comparatively recent invention of the wheel, man learned to form pottery by centering a piece of wet clay on a flat spinning disk—"wheel throwing," as potters call it today.

Centuries before Christianity, advanced cultures in China and Egypt began adding sculptural elements to their pottery, usually in the form of decoration of ceremonial vessels. The handle in the shape of an animal sipping from the lip of a beaker, for instance, was an early motif that appeared all over the world.

While potters of early Chinese dynasties and Japanese Haniwa potters of the fourth and fifth centuries A.D. produced ceramic sculpture of equal though contrasting sophistication, it was in Mexico that clay figurine sculpture reached perhaps the greatest heights ever known. In Mexico, the Mochica potters of the first and second centuries B.C. and the pre-Columbian potters of the late Classic and early Post-Classic periods (A.D. 700–1200) made magnificent figures in very simplified terms, representing many facets of everyday life. These potters are responsible for much of what we know today about the arts and customs of those extraordinary early Western societies—in which the wheel was unknown—that flourished before the arrival of Columbus in the New World.

The pre-Columbian potter, incidentally, often constructed rectilinear forms of "slabs" of clay, rolled out or cut from a cube of wet clay with a string or wire. Using such slabs very

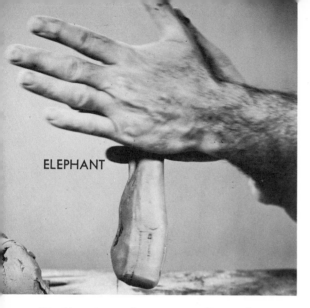

ELEPHANT

15—Here is another way to roll out clay.

16—Curl up one end and press in a snout.

17—Slap out two pancakes for ears . . .

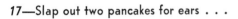

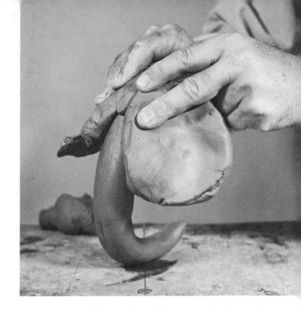

18—and attach to heavy end of trunk.

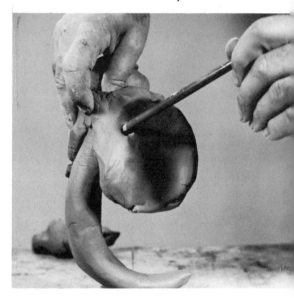

19—Just punch two holes for his eyes,

20—and there is your elephant.

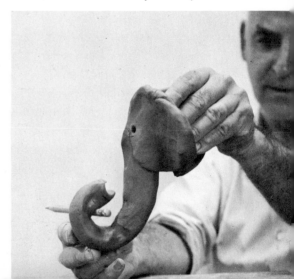

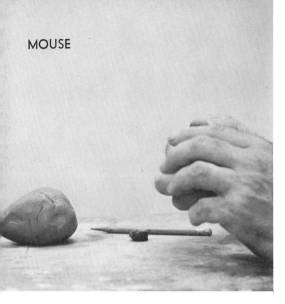

21—Now form a pear shape.

24—Again, a pencil to make the eyes,

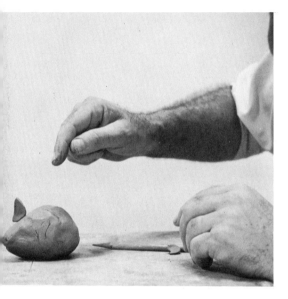

22—Add a couple of small, flat triangles

23—for ears, and pinch out a nose.

25—a coil rolled out for a long tail,

26—and suddenly there is a mouse!

19

DUCK

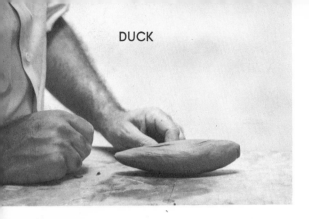

27—Now start with a fat cigar shape.

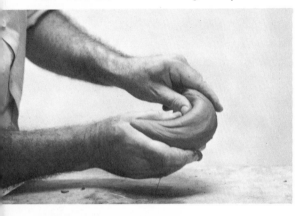

28—Bend it into a curve.

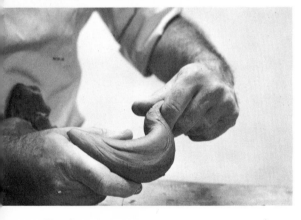

29—Squeeze a reverse curve on one end.

30—Squeeze tip into a duck's bill.

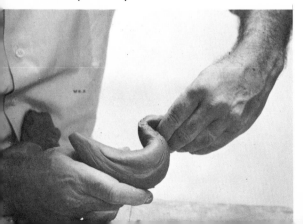

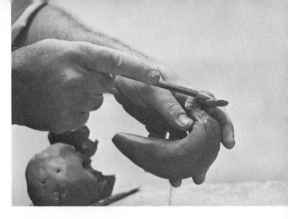

31—Indent eye sockets with pencil point,

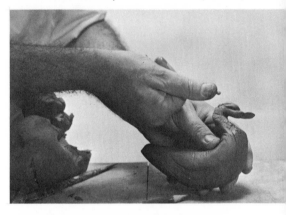

32—and add two balls of clay for eyes.

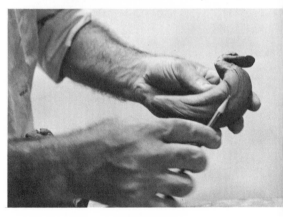

33—A couple of bold lines suggest wings,

34—and your duck is ready to swim.

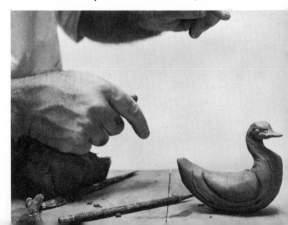

BEAR

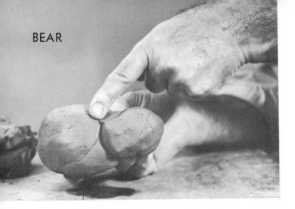

35—Stick two balls of clay together for a

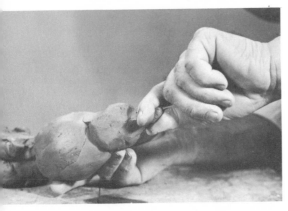

36—body and a head, then pinch out a nose.

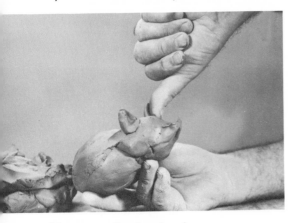

37—Add two small triangles for ears,

38—and two larger pieces for the jowls.

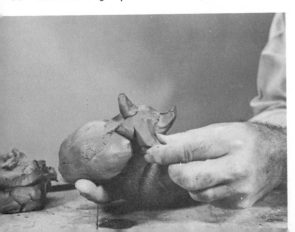

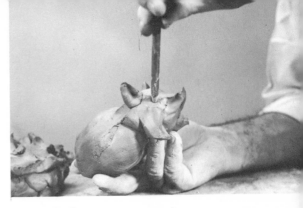

39—Once again put in the eyes.

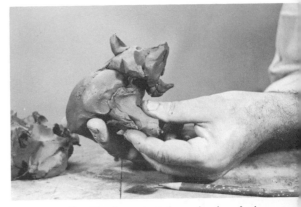

40—For the legs, just four chunks of clay.

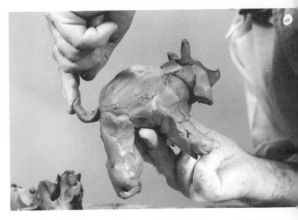

41—Add a little tail, then turn up ends

42—of each leg to make bearlike paws.

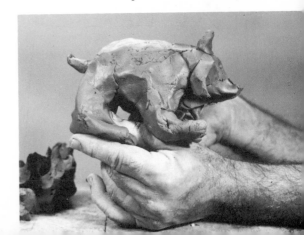

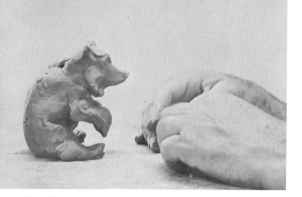

43—Now your bear can sit up or . . .

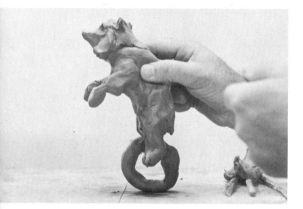

44—ride a circus unicycle. If he falls,

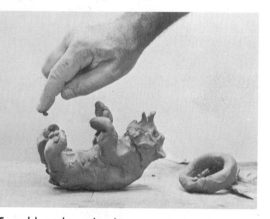

45—add pads under his paws. When he gets up,

46—introduce him to an old friend.

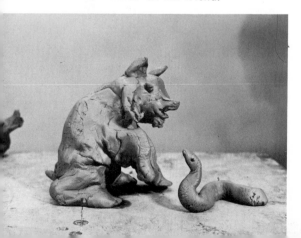

wet and very thin, he displayed perhaps his most extraordinary facility in the representation of clothing on ceramic figurines.

SELF-SUPPORTING WET-CLAY MODELING

The modeling demonstrated in the various process picture series—except for the female torso—are examples of self-supporting sculpture in modeling clay kept moist with water. "Self-supporting" (or "unsupported") simply means clay modeled without an inner framework (armature) to hold up the form. Sculpture of any real size, it should be understood, ought to be supported with an armature, and, if you are wondering how armature-supported pieces are fired, the answer is simple: they are done on a simple metal or wood armature. When the clay has dried out hard enough after modeling to support itself—but is not completely dry—the statue is cut in half vertically, the armature removed, and the two halves hollowed out. Then they are sealed together again with a soft paste of water and clay, after the edges that meet have been lightly scored with a toothed tool.

THE ARMATURE

For learning to think in three dimensions with clay, an armature may be found to be a handicap—it limits the bending and twisting and general shaping of your developing form. An armature, if you are seeking facility in the medium, is something to be avoided in sketching in clay. After you have made your small sketch, you may very well want to use an armature for your larger, more finished work, but by that time you will have decided exactly which way the figure will bend

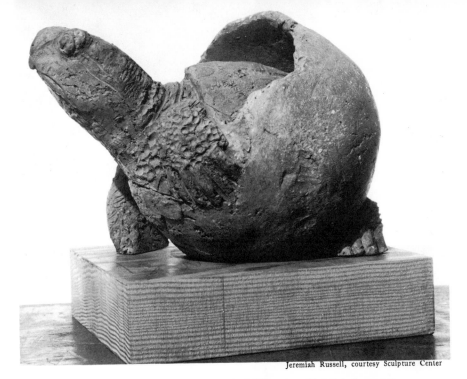

Jeremiah Russell, courtesy Sculpture Center

47—Above: Terra cotta, 8″ high, entitled "Coming Out," is by contemporary sculptor Dorothea Greenbaum.

48—Below: Duck, 7″ high, is a clay pot in the form of a bird from the Tlatilco culture of western Mexico, ca. 1500–300 B.C. Lee Bolton, courtesy, André Emmerich Gallery

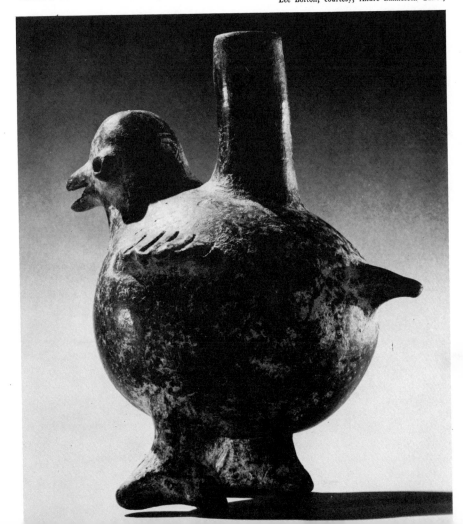

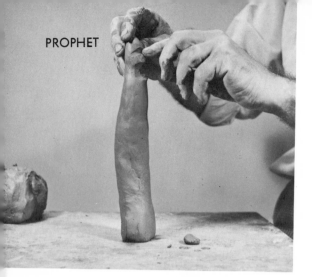

49—At end of long roll of clay, groove out

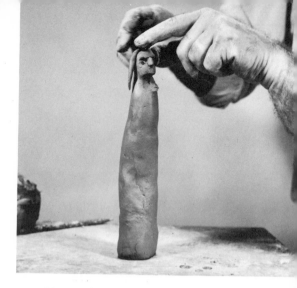

52—apply as lanks of hair. With smaller

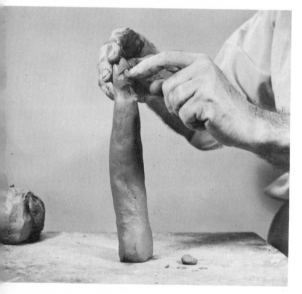

50—neck and eye sockets; add a nose.

51—Roll out small spaghetti-like forms and

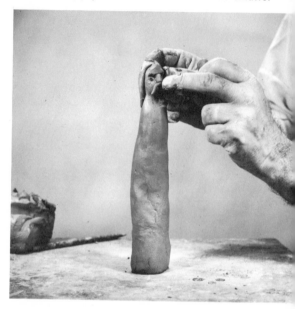

53—rolls, make the mustache, and under it

54—add whiskers, pressing them into place.

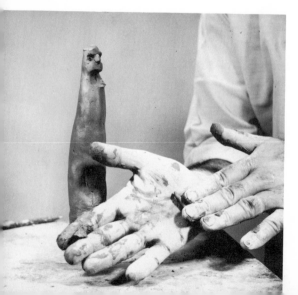

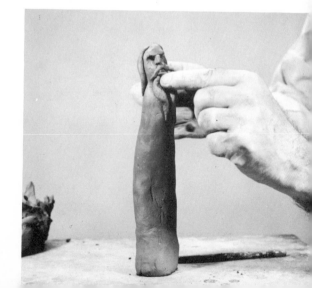

55—Open the mouth.

56—Place whiskers on sides of the face.

57—Add little balls for eyes in sockets.

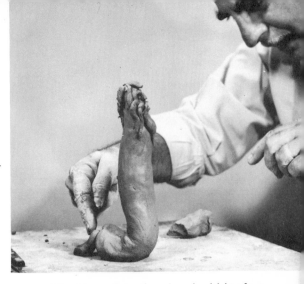

58—Have figure kneel and add his feet.

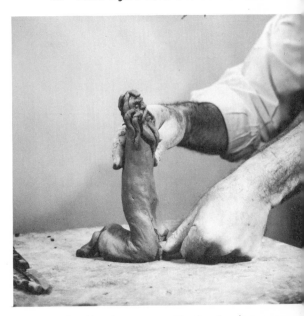

59—Simply gouge with thumb—legs separate.

60—Curved coils make folds in robe.

61—Add two arms, which are held out from

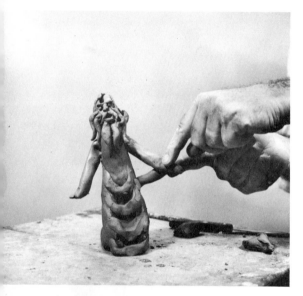

62—body by more coils representing folds.

63—Add shape of hands with thumbs, and articulate the form for expression.

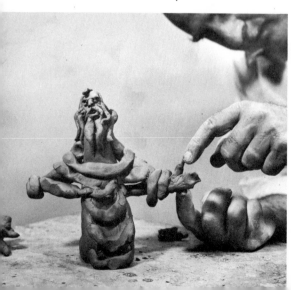

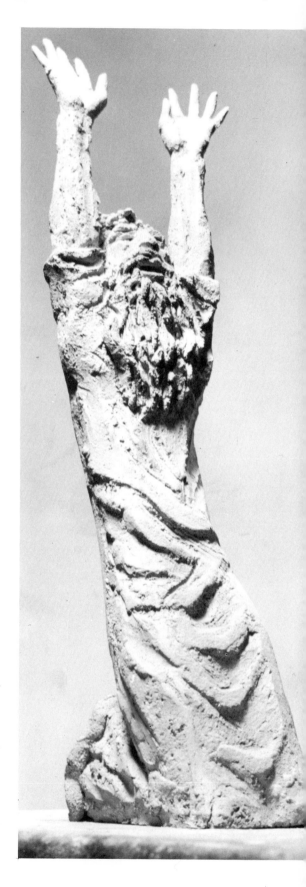

26

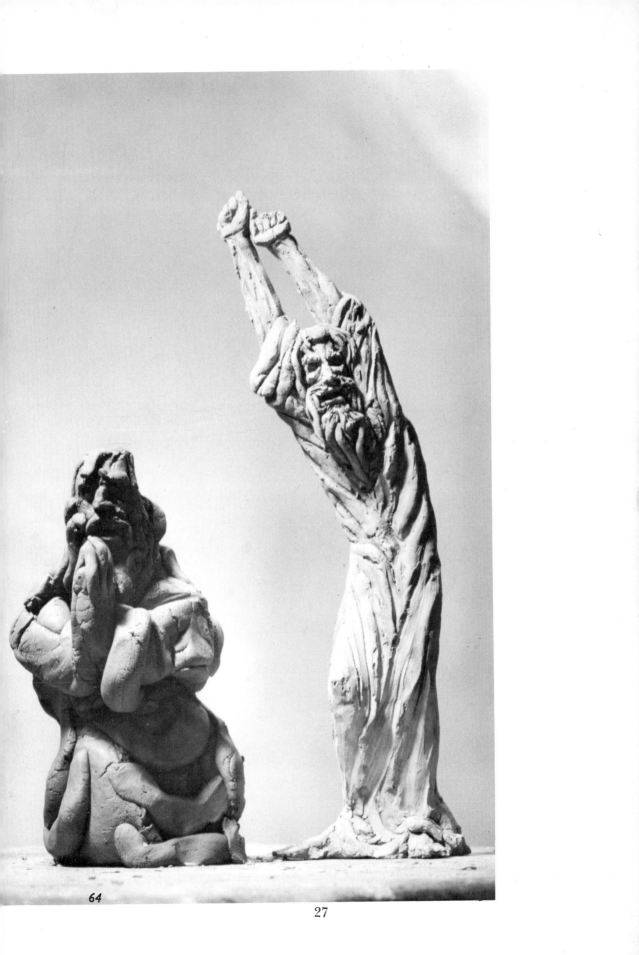

64

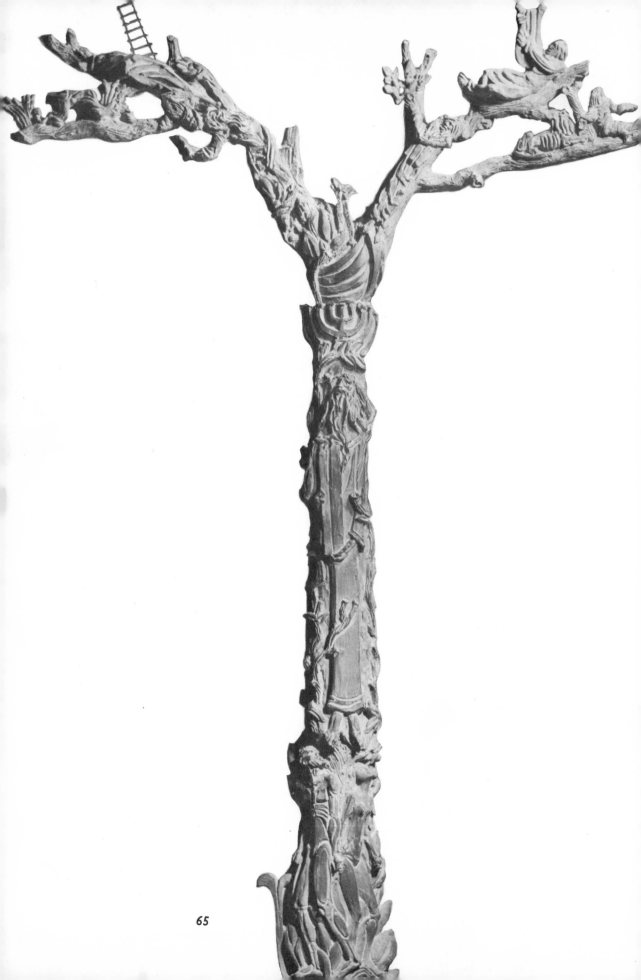

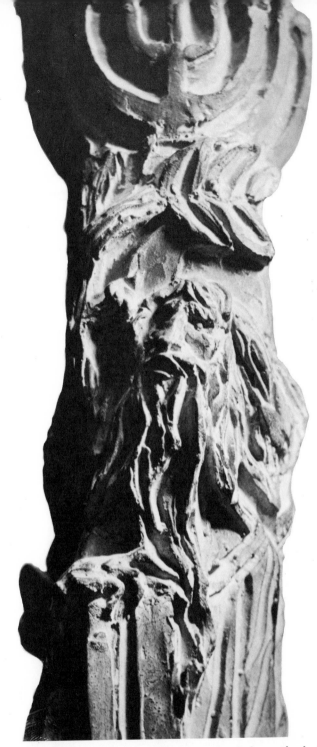

65–68—Detail of Moses, central figure of the author's 9-foot-high clay sculpture "Burning Bush" (facing page), a model for a full-scale statue. It has been given a patina to look like bronze. At the base can be seen Adam and Eve (detail following page); above them Moses holding the Ten Commandments; then the ark, David playing the harp, and Daniel in the lion's den as elements of the right branch; and Jacob's ladder followed by Moses in the bulrushes in the left branch. In modeling, the work has been supported by a simple armature. The branches, done separately, join the main trunk just above the seven-branched candelabrum. Detail of right branch is shown on page 31

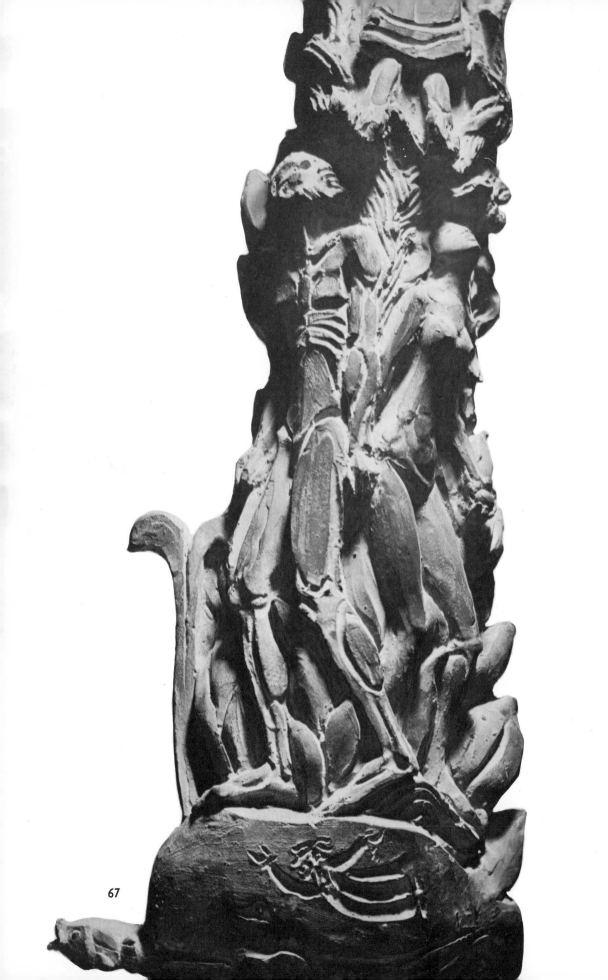

67

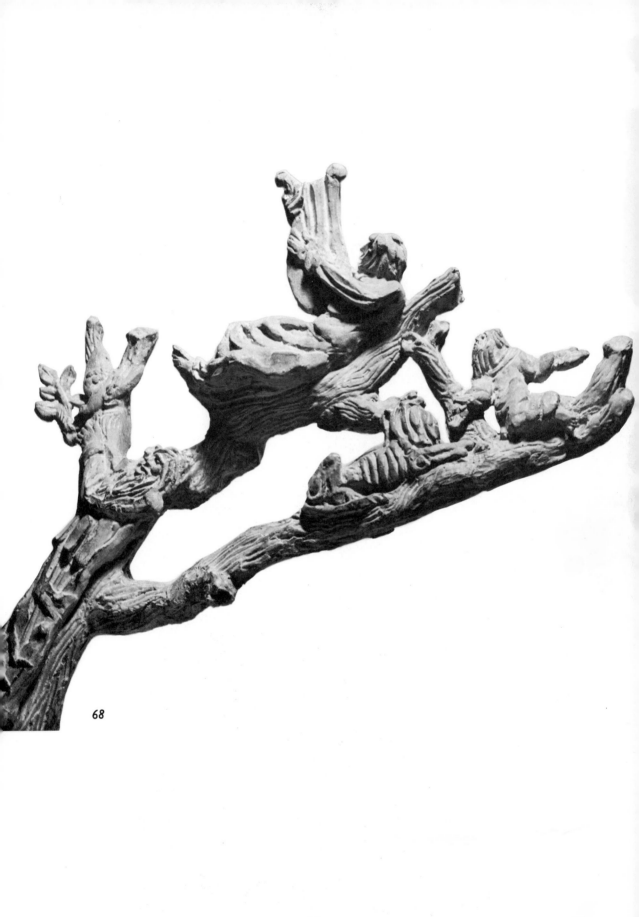

68

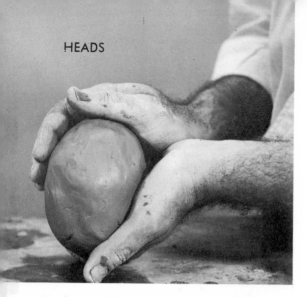

69—Start with egg and divide down center,

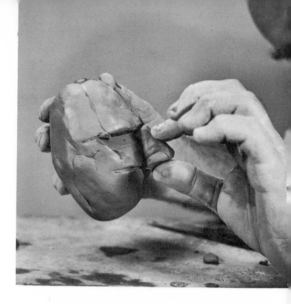

72—Triangle for nose spans center section.

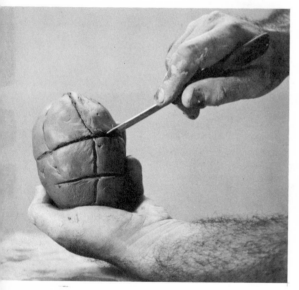

70—across at mid-point, and lower part in half.

71—Cut out the eye sockets.

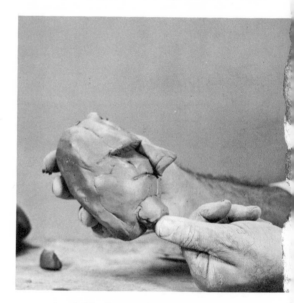

73—Add chin on bottom of egg.

74—Coils form lips between nose and chin.

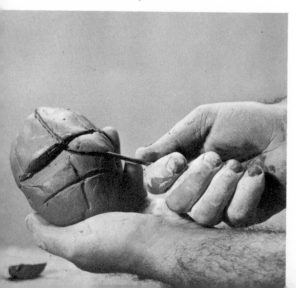

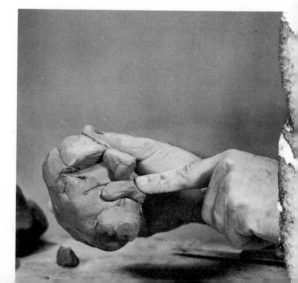

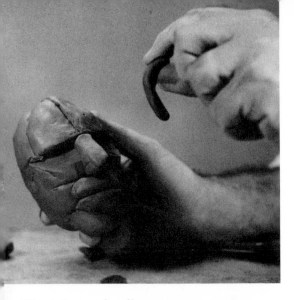

75—A teacup handle, same span as nose,

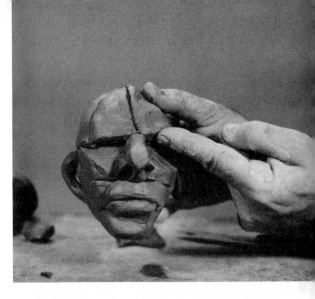

78—Press up to form the eyebrows.

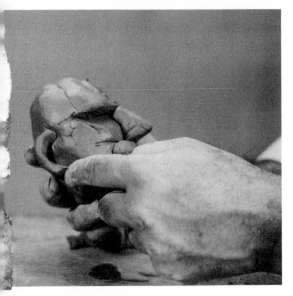

76—forms the basic ear of any head.

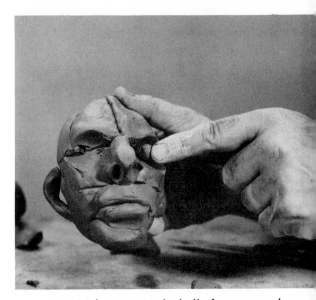

79—Make two simple balls for eyes and add hair.

77—Press up to form the two nostrils.

80—You now have the basic head.

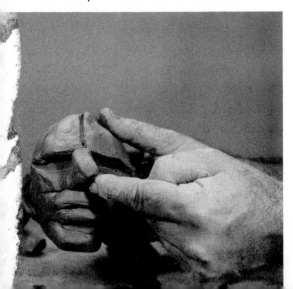

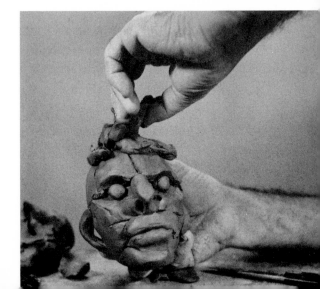

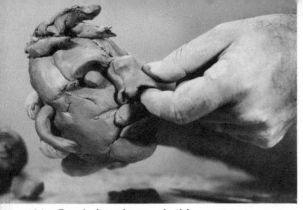

81—For Indian brave, build up nose,

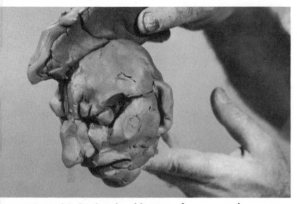

82—add high cheekbones, frown, and a forelock.

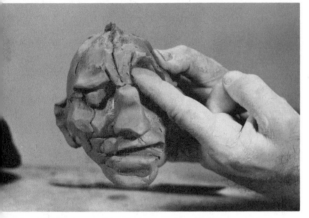

83—To turn him into a prize fighter,

84—push eyebrows into punchy look, break the

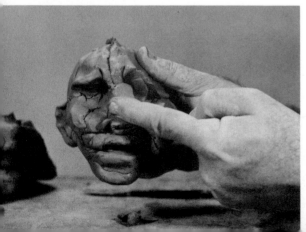

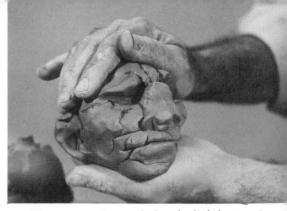

85—nose and squash head slightly to chang

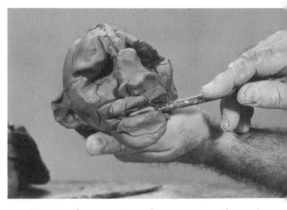

86—total expression. Open up mouth, and

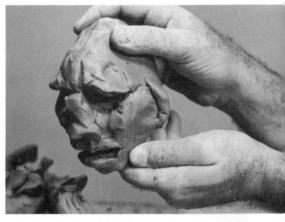

87—with cauliflower ears—a prize fighter.

88—Now smash the face and see what you get.

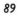

34

89

125–126—Clay figures done between A.D. 300 and 900, in Las Remojades style of Veracruz, Mexico, are the 8"-high priestesses below and the 10½" standing figure on the facing page. Evident is the use of simple, rolled-out elements—coils and little balls pressed in place—to give form and character to the modeling. The priestesses' headdresses, clothing, and the platform on which they are kneeling show extraordinary facility on the part of some pre-Columbian potter in the handling of wet slabs of clay.

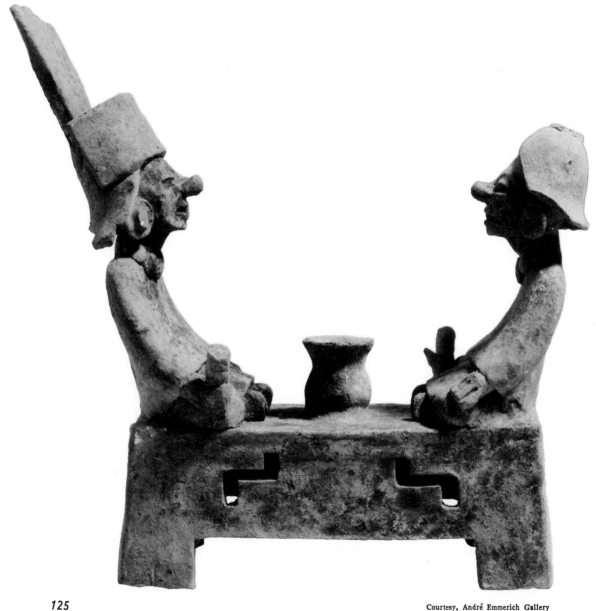

125

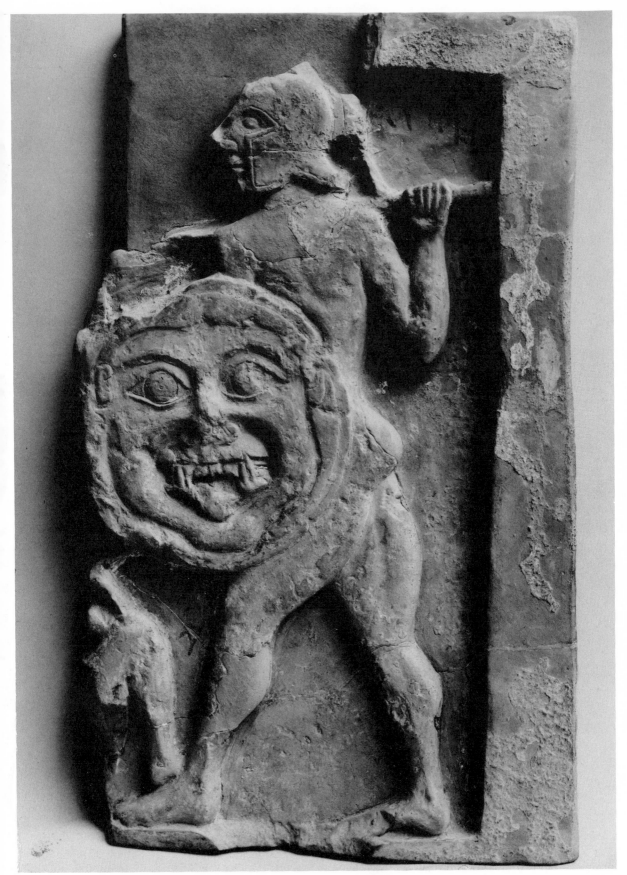

Courtesy, The Metropolitan Museum of Art, Samuel D. Lee Fund, 1942

124

49

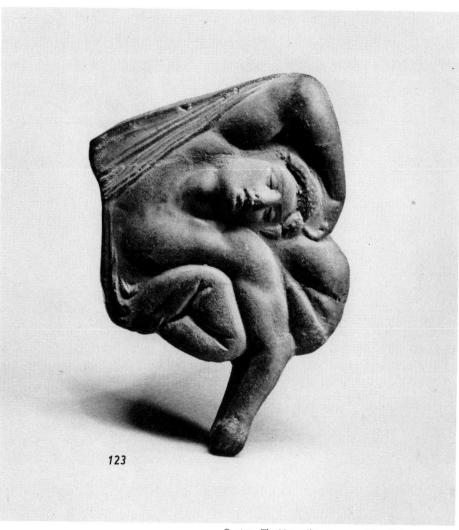

123

123–124—A deep emotional quality with a minimum of detail is achieved in this small Roman terra-cotta relief of a sleeping youth done about the time of Christ. From Arrezzo, it was a stamp used in the making of Arrentine relief ware. Facing page: A much earlier Greek relief, late seventh to early sixth century B.C., is this detail of a scene from the Trojan War, depicting Achilles, the head of a gorgon on his shield.

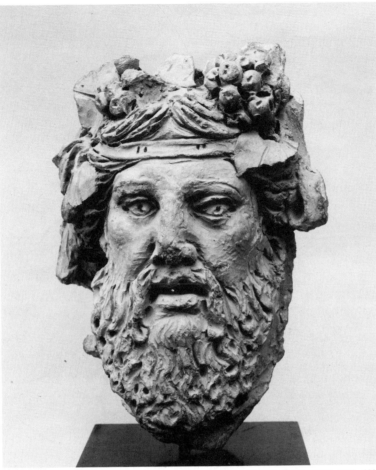

122—While the torso on the facing page is a finished statue, a sketch quality demonstrating great facility in the medium is captured in this clay Roman head of Dionysius wearing an ivy wreath.

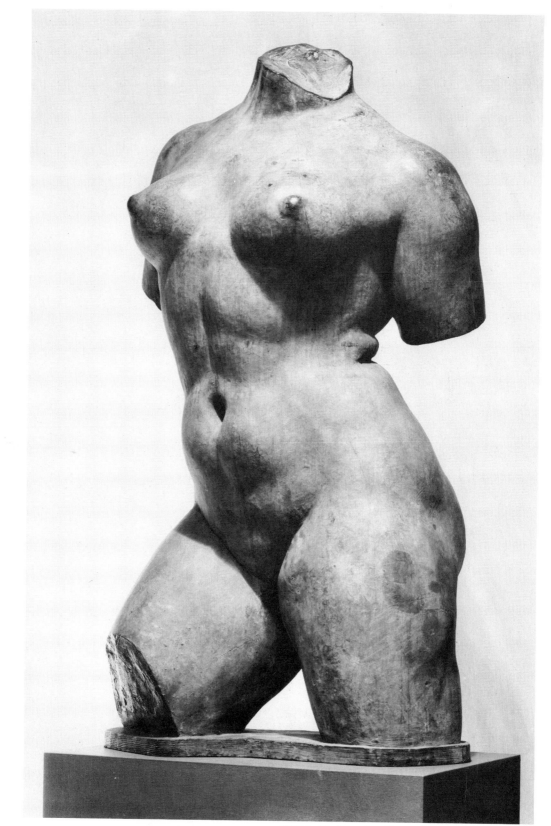

121—Torso in clay cast in bronze is by French sculptor, Aristide Maillol, who died in 1944.

REDESIGNING THE HUMAN FIGURE

From the beginning of recorded time, the artist has taken liberties with the form of man in order to make some point. In fact, it is difficult to think of an example of fine art in which proportions of the human figure have not been altered in one way or another to gain an effect—not to exaggerate emotion *in* the figure so much as to accentuate the emotional impact *of* the figure on the mind of the onlooker.

The famous head of the Egyptian queen, Nefertiti, one of the most beautiful of all portraits, has a neck longer than normal and eyes that are not quite like eyes as we know they are; her head has been redesigned to represent the artist's ideal of grace and beauty in his day.

In the Middle Ages the attenuated figures done in stone and polychromed wood for cathedrals were designed to echo the upward sweep of Gothic architecture.

The point is, a little exaggeration is not noticed as exaggeration. Well done, it does emphasize emotion—and this is what gives the artist that edge. Indeed, it is the artist's prerogative to take the human figure as it really is and use that as the jumping-off-place to say what he wants in expressing his own individuality. In doing so, the only inviolate laws are anatomical ones: he can exaggerate the human figure in many different ways but he cannot change the articulation of it— the joints bend only in specific prescribed directions.

120

45

115—Add in breastbone up to shoulder.

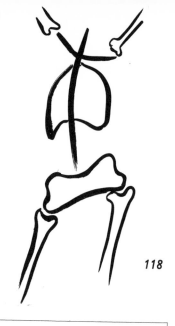

118

116—Blend salient features into single

It may help you to remember that the skeleton is the armature of the human body. From the pelvic bone to the base of the skull, the backbone is composed of little vertebrae that allow the body to bend in any direction, very much like a gooseneck lamp. The other parts of the body can only bend at the joints in certain specific directions. There is another basic truth to keep in mind when modeling the human form. If a person stands on one leg, the hips slant down toward the leg the weight is on, while the shoulders always slant in the opposite direction. This is called the Law of Opposition.

117—integrated form for finished sketch.

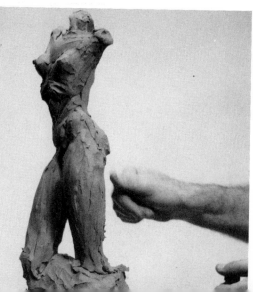

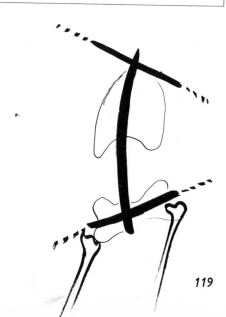

119

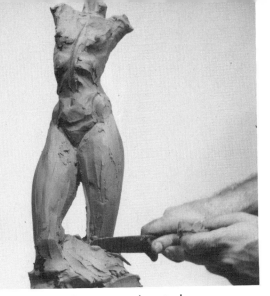

109—Trim down upper legs to knees.

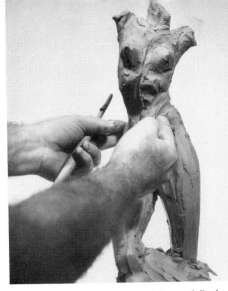

112—Emphasize folding of flesh at waist.

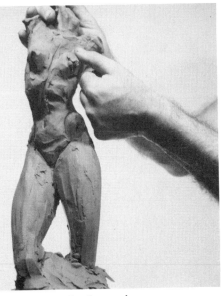

110—Accentuate the form wherever
needed.

111—Turning the figure, add shoulder
blades.

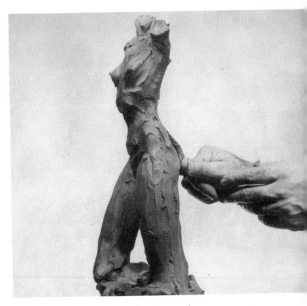

113—Fill out the buttocks.

114—Bring out the underlying ribs.

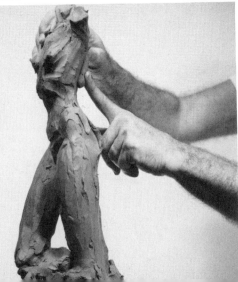

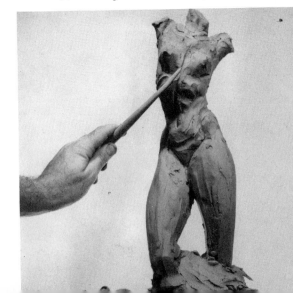

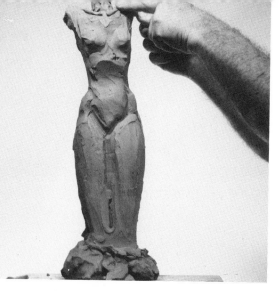

103—Add collarbones.

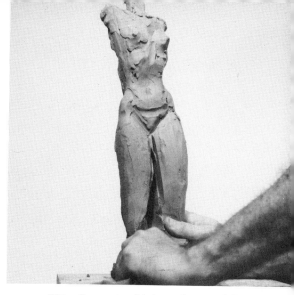

106—Separate thighs with a modeling tool.

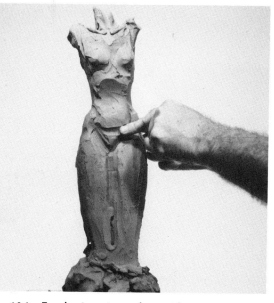

104—Emphasize stomach muscles.

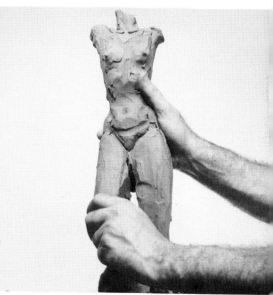

107—Bring one leg forward.

105—Twist form for more dynamic pose.

108—Emphasize center line of rib cage.

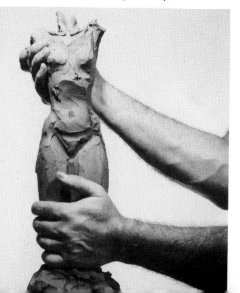

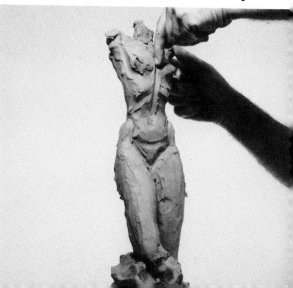

THE TRANSIENT MEDIA

Until it is either baked or cast, clay must be considered a nonlasting or transient medium. As venerable an art form as is wax, it too must be considered transient until it is cast. These transient media are the ones for sketching with which you capture your ideas. Other media, like stone, all involve long lapses of time between the initiation of the execution of an idea in three dimensions and its final execution. The vitality and life so evident in a Rodin clay sketch or a Degas wax figurine stem directly from the speed of execution of the fleeting idea that each represents.

I always make my students throw away their first efforts to avoid any predilection toward preciousness in the early stages of learning. Once you gain proficiency, however, you should keep everything you make.

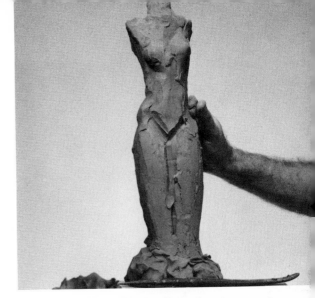

100—Add clay for pelvic bone and

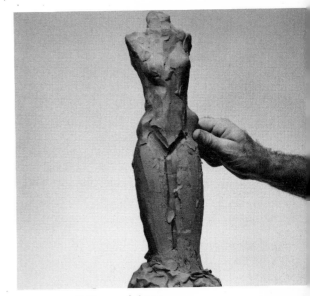

101—model it in.

102—Cut out chest cavity.

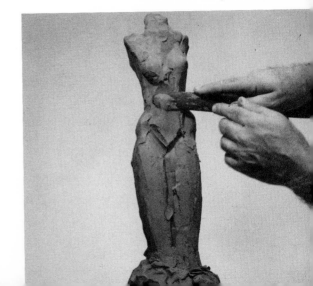

41

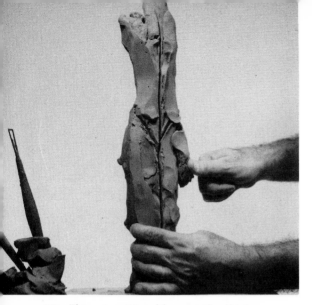

97—Thin at waist, add on at the thighs.

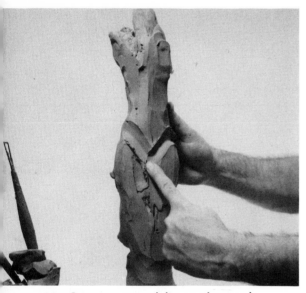

98—Groove out to delineate legs and body.

99—Add clay to fill out breast line.

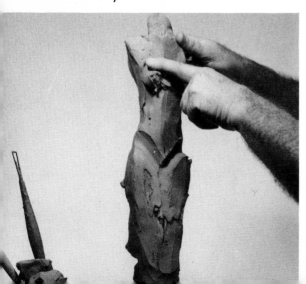

A statue with any bulk should be hollowed out from the bottom before it dries. If you can make the body of your piece about the same thickness throughout, your chances are much better that it will not crack when drying, or blow up when fired. A work of clay has to be bone dry before it is fired. Usually a couple of weeks' drying time is required to get all the moisture out. You can dry it in the sun—the way the Southwest Indians still do—or on a radiator in the wintertime.

Try to work on a flat "bat" of plaster of Paris (just a slab you pour yourself into an area surrounded with a 1- or 2-inch wall of cardboard). This is a better method, because a wooden stand or table will sometimes warp from the water you have to use when working clay—whereas a plaster bat will absorb the moisture as you go along.

If you inadvertently let a statue get too hard to work before it is completed, you can still save the clay. Simply chop it up in little pieces and put it in a crock with water. Eventually, it will turn back into a completely plastic mass.

Clay, remember, is a nice clean medium that washes off your hands easily; if it gets on your clothes, you can brush it off when it dries.

instantaneous response, a rapport between the medium and the artist, that you feel when you work the clay directly with your hands—an important communication that tools, many times, only seem to stultify.

HOW TO TAKE CARE OF WET MODELING CLAY

All your work is for nothing if you do not take care of your clay. Let us assume you have bought it at the right consistency—it comes in tin cans or plastic sealed boxes. As you work it, the clay naturally will dry. As it does so, it will begin to crack and break. (Sculptors say the clay is "short" when it gets like this; when it is perfect, they say it is "silky.") At this point you simply add a little water to the clay you are working by merely wetting your fingers, or, with an atomizer or a spray gun, spray a fine film over the sculpture. Experience will soon show you the amount of added moisture needed to keep the clay workable. I made the snake, the mouse, the snail, the elephant, and the duck all out of the same piece of wet modeling clay (not to be confused with plastilene) in a single morning without having to add any water until the final figure. But my clay was a perfect consistency when I began.

Always make sure that the clay is covered and airtight when not in use. It is a good trick to keep a damp sponge right in the container with your clay.

When doing a statue that has to be left for any length of time, a plastic film bag pulled over the work will keep it pliable until you can get back and finish the job.

TORSO

94—Aluminum wire armature on a board

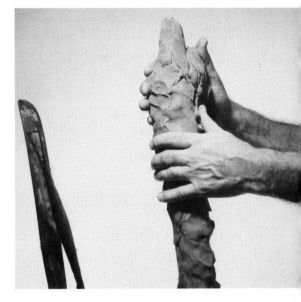

95—is packed with plastilene pressed on.

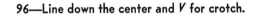

96—Line down the center and *V* for crotch.

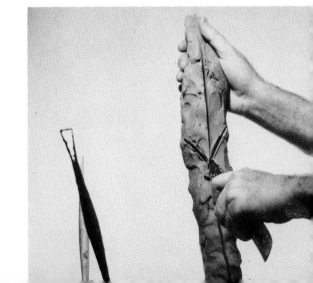

—you have your armature's proportions.

An armature can be as simple as a stick of wood anchored in a base, or as complicated as a welded steel and lath construction for supporting a very large figure without having to use hundreds of pounds of clay.

For small work always use an armature that can be bent. Light, strong aluminum wire is better than lead, and, though slightly more expensive, comes in a great variety of thicknesses.

If you are making a small piece in clay to be fired, avoid an armature unless you use something very simple, like a dowel, which, when the clay gets leather-hard, can be slid out easily without the statue collapsing. Be forewarned that the technique of cutting your whole statue in half to get the armature out as described above is a rather tricky business.

PLASTILENE

What is plastilene (or "plasticine") and when is it preferable to clay? Plastilene is clay suspended in oil and wax instead of water to make it pliable.

Wet clay is the better all-around medium for sculpture, but there are cases where plastilene is preferable— as when considerable time must be spent on a project and drying out becomes a problem. For the person who can work only at odd moments at his sculpture, plastilene enables him to leave it and come back and start right in. Therefore, plastilene is usually used by sculptors for very large work.

Sculpture done in plastilene must always go through another process, however, to be made permanent. It has to be cast in plaster and then cast again from the plaster cast into an even more permanent medium like bronze.

Professional sculptors use Italian plastilene, which is very expensive. Four or five times more costly than clay suspended in water, plastilene will outlast the sculptor no matter how often he uses it and still be as good as new.

Of the two, I personally feel wet clay is a more sensitive medium because you can control the plasticity.

TOOLS FOR MODELING

Everyone develops his own preferences in tools, but there are a few that cannot be done without. An ordinary kitchen knife is very handy for cutting and hollowing out. There are certain surface textures that small, inexpensive modeling tools can impart to the clay that your hands cannot. A flat wooden tool, one end pointed, the other end toothed, is very useful. Orange sticks make fine tools for modeling small features. A pencil sharpened in a pencil sharpener is good, too. With just these few tools there is no effect that cannot be achieved, although there are many tricks you will discover for yourself as you work along—like repeatedly pressing the butt end of a rough-sawed board or a stone into the surface of the clay for creating an allover texture. Though these are matters of preference, nurture them, for they can develop into an individual style.

When all is said and done, however, the fewer tools you use the better. The more you depend on your fingers in preference to inanimate tools, the "freer" your final results. There is a transference of life from your fingers that imparts character to the clay—an

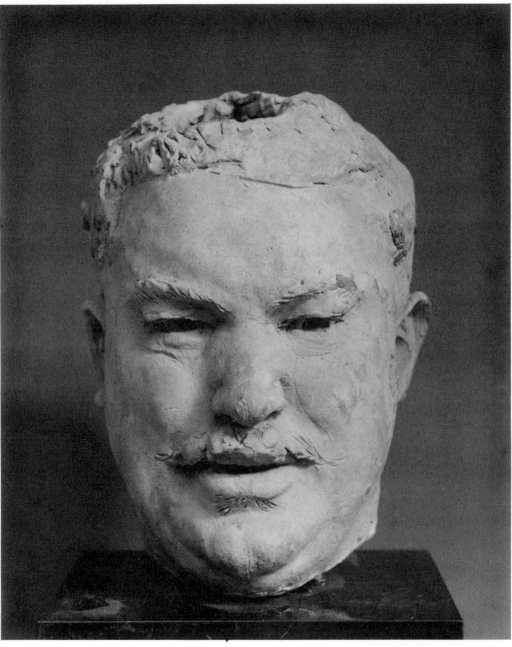

93

90–93—Four approaches to the human head in clay. On preceding page: Man's head with crocodile helmet, from Veracruz, Mexico, A.D. 700–1000, 14″ high. Right: Smiling boy, 8″ high, from the same time and culture. Facing page: Auguste Rodin's famous study of a head of Balzac done early in this century and slightly over life size. Below: Girl in a straw hat by contemporary sculptor Dorothea Greenbaum, 11″ high.

92

Charles Uht, courtesy Museum of Primitive A

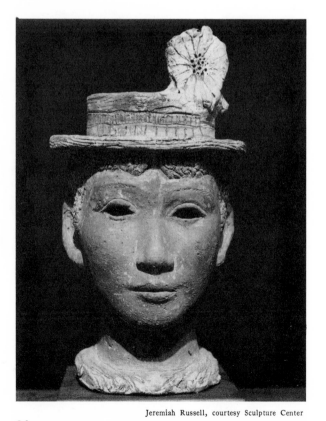

Jeremiah Russell, courtesy Sculpture Center

91

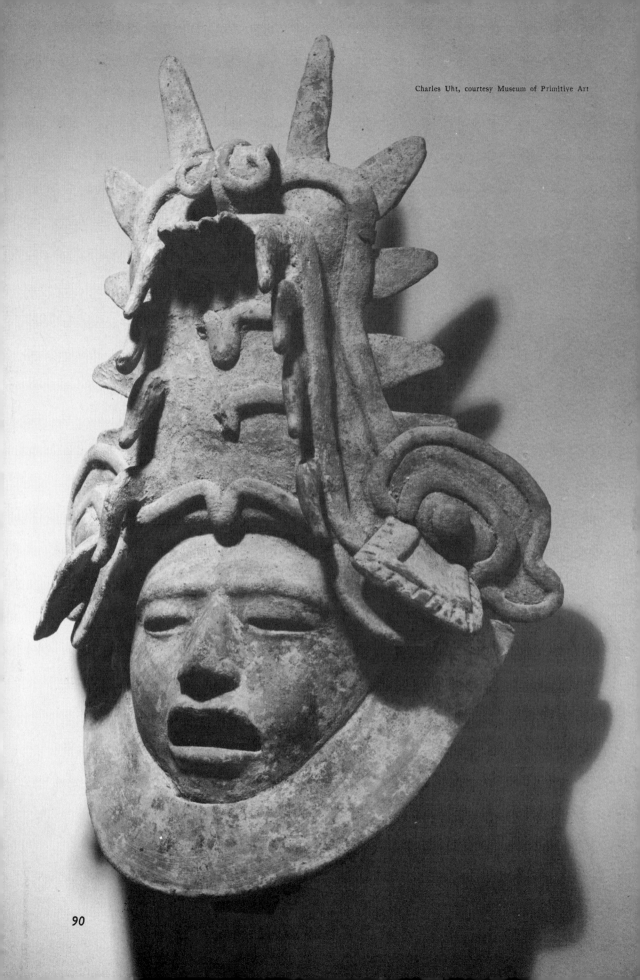

Charles Uht, courtesy Museum of Primitive Art

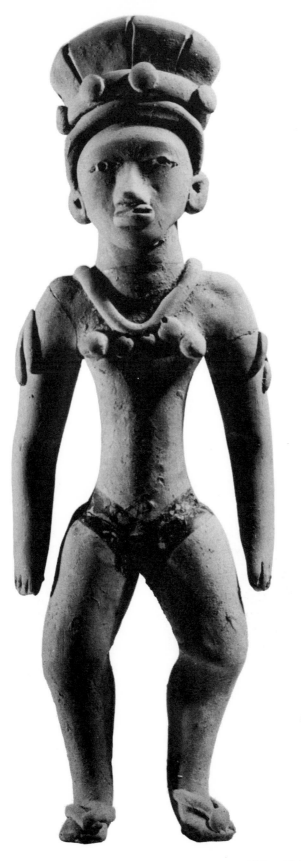

126

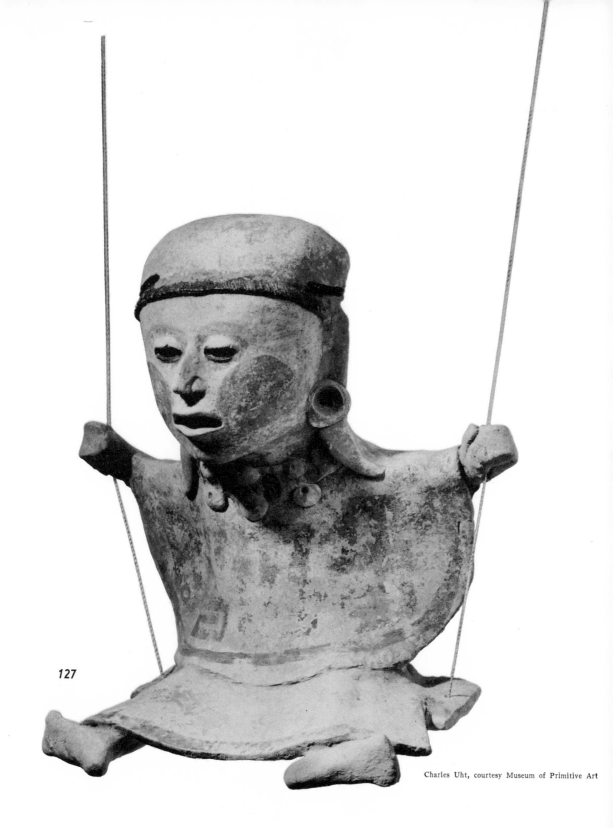

127

Charles Uht, courtesy Museum of Primitive Art

127–128—Facing page: For visitors to New York's Museum of Primitive Art, one of the most popular figures has been the 10″ swinging girl in Las Remojades style of Veracruz, Mexico, A.D. 700–1000, in which the clay has been decorated with paint rather than glaze. Simplifying form still further is the magician below, 7″ high, done in Mexico's archaic Colima style, A.D. 300–800.

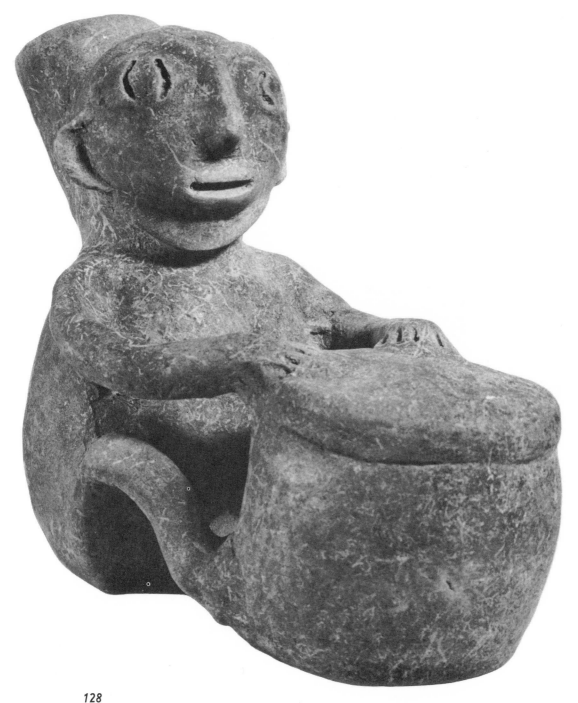

128

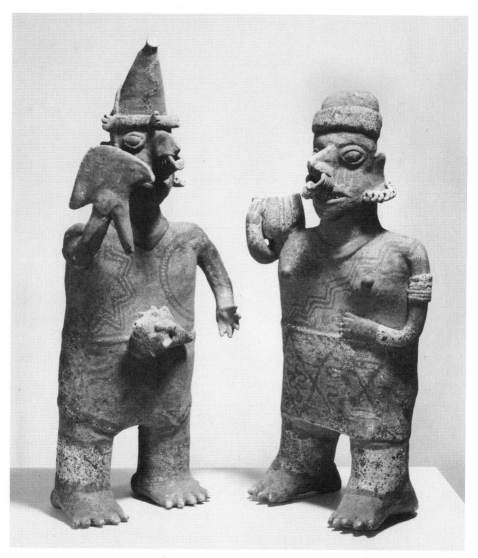

129—Marriage couple from the Nayarit culture
of western Mexico, *ca.* A.D. 300–900, 17" high.

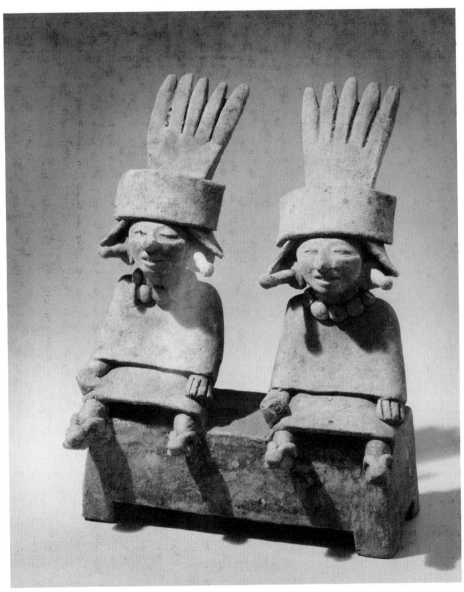

130—Giving every appearance of a representation of identical twins are these 9″-high seated figures in Las Remojades style of Veracruz, A.D. 700–1000.

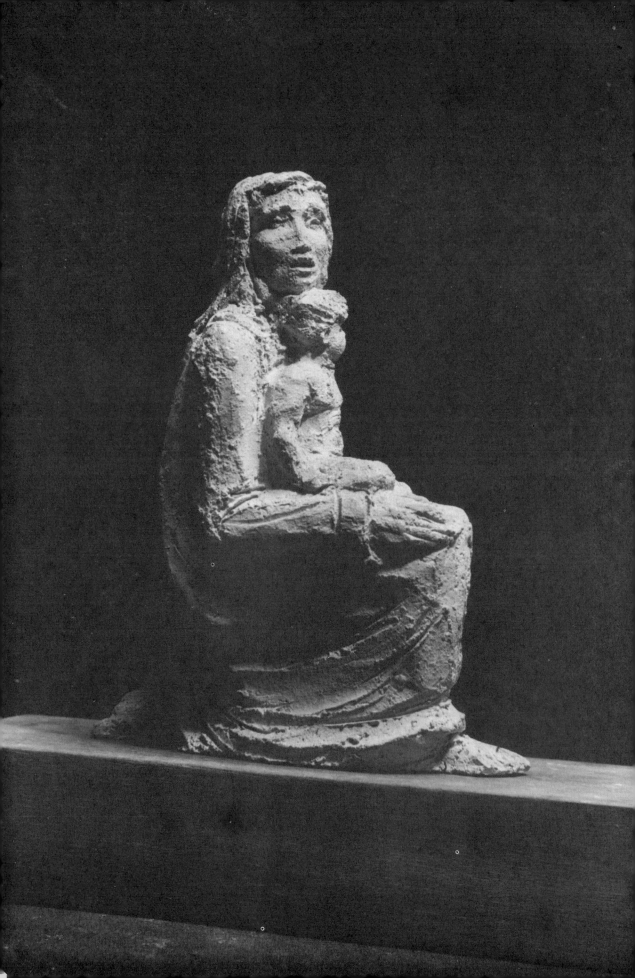

131—Mother and child by the author, 10″ high, in terra cotta. The modeling of the figure and even the baby purposely have been left roughed-out and sketchy to draw the eye to the most important element, the expressive face of the mother.

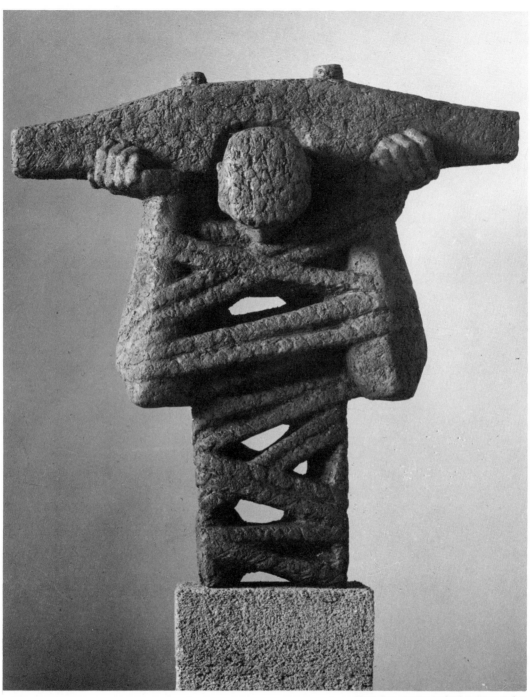

132—"The Yoke," 15" high, by Henry Rox, is unsupported sculpture built up of little pellets of wet clay. It is a demonstration of the complicated forms possible in this inexpensive medium.

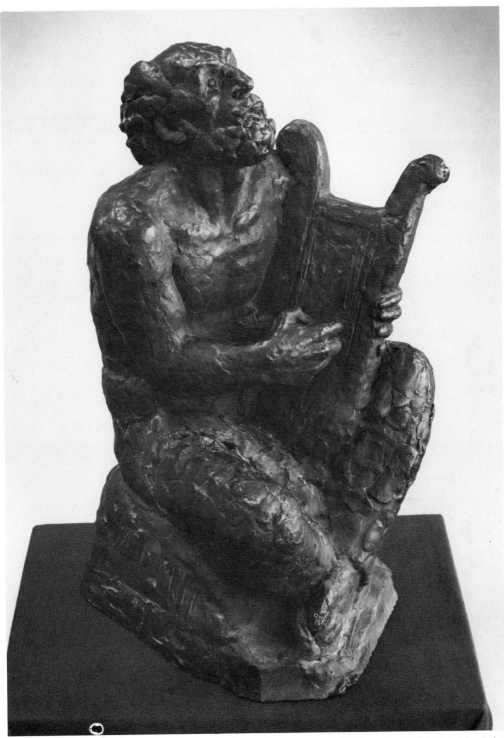

Oswald Werner, courtesy National Sculpture Society

133—This statuette of the blind bard, "Homer," by modern sculptor Ivan Mestrovic, illustrates a totality of emotional impact possible with a minimum of detail in a figure.

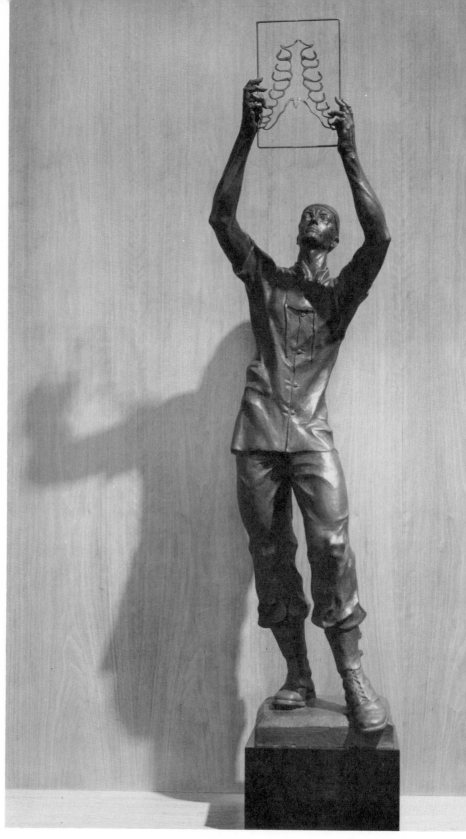

134—An example of a finished statue from an original done in clay is the author's "Point of Decision," World War II war memorial for the Cornell Medical School.

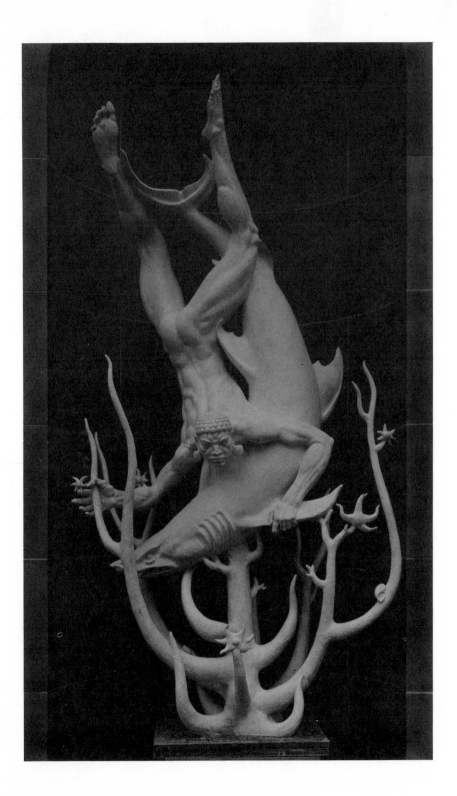

135—Another example of finished statuary is this 6' "Shark Diver" in plaster, the model for a bronze by the author.

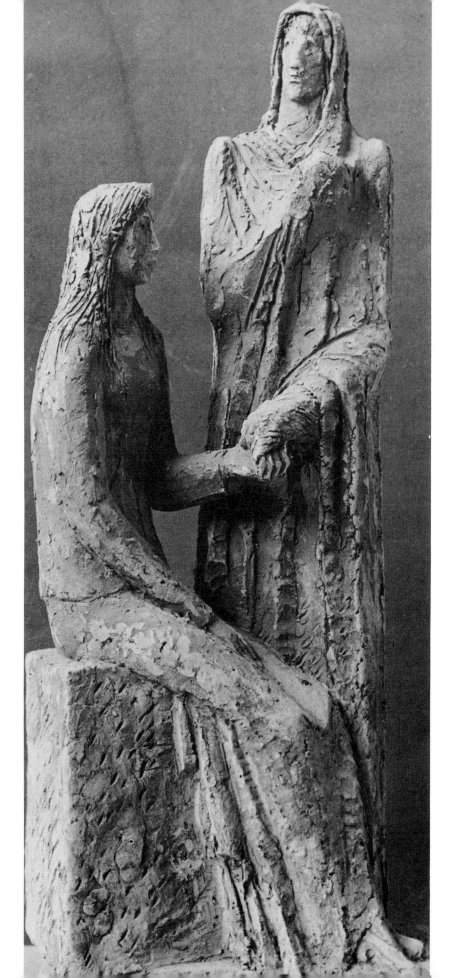

136—**Terra-cotta sketch** by contemporary sculptor Henry Kries is 20″ high.

WAX

Wax in the form of beeswax is one of the natural raw resources that man early discovered he could manipulate into form. We know that the ancient Egyptians were familiar with the lost-wax process, and wax models of religious figures have been found perfectly preserved in ancient tombs in Egypt. The Greeks made dolls of wax for their children to play with, as well as replicas of their deities as votive offerings. When important members of the family died, the Romans (at least those from the nobility) made death masks which they carried in funeral processions. In fact, most early Roman metal objects—usually bronze —were cast from wax models. During the Renaissance, Italian masters did extensive modeling in wax and cast their work by means of the lost-wax process. Good examples of wax formed with hot tools are the portrait medallions so popular during the early eighteenth century in England and the American Colonies. In this century, the great French impressionist, Degas, although he is better known for his painting, did a good deal of sculpture in wax. He seldom carried these figurines beyond quick sketches, but in his magnificent dancers and horses he caught the frozen instant of life with a spirit seldom equaled with so much candid feeling. The Degas statues were recently put on exhibition at the Metropolitan Museum in New York City, with the result that the public and critical acclaim accorded them has brought a new realization of the possibilities of this all-but-forgotten medium.

Although today wax is the least used of the three media, clay, wax, and slate, it offers the sculptor the greatest scope in small-scale work. Wax permits great fluidity of form and will take an extraordinary amount of bending, twisting, and reshaping without disintegrating. It is a clean material you can carry in your pocket to work at whenever the whim strikes you.

Available as beeswax in the ten-cent store, the wax that sculptors use, called "Microcrystalline," is a synthetic the color and consistency of beeswax but considerably cheaper. Its consistency is controlled in manufacture, and it is available in several degrees of hardness. Although some sculptors like to use a harder grade in summer and a softer one in winter, I buy a wax of medium hardness and use the same grade the year around—it is the grade generally designated by art suppliers as "Microcrystalline for Modeling," and it comes in blocks.

Wax is more permanent than any of the other transient media. It does not flake or powder or warp or get eaten by insects. If the unsupported appendage of a figurine slumps in summer's heat, it is an easy matter to right it again.

Unlike clay or plastilene, wax never sticks to your fingers more than slightly—and even that can be overcome by wetting your fingers with the tip of your tongue. A pencil sharpened in a pencil sharpener makes a fine tool for modeling delicate features in wax, and for pressing parts like lanks of hair in place to make them join the piece you are working on.

The way to get one piece of wax to adhere to another is simply by pressure. If you want to join two delicate forms that would lose their shape if they were pressed together, simply heat the blade of a knife in a flame

and run the hot tip around the point where they meet. When the little line of melted wax hardens again, the two parts will be joined. Some people do all their modeling in wax with a hot spatula-like tool.

But wax sculpture worked without heat seems to have a more facile look. The sketch quality you seek is acquired most easily and quickly by learning to work the wax directly with your fingers.

Holding the wax in the palm of your hand will soften it to the desired plasticity, or you can place it in the direct sun or on a radiator to soften it for working. The heat given off by the small radios that most of us have today is perfect for keeping your wax at just the right consistency for modeling. If it gets too soft while you are modeling, you can put it in a cool spot for a few minutes or dip it in a bowl of cold water. Do not try to work it when it is wet, however, as wet wax just will not stick to itself. A large figurine, such as a horse, done without an armature can be braced with sticks of balsa wood that in casting will serve an additional purpose. The wood will burn out easily and form a passage so the hot metal can run freely to the more remote parts of the statue—such as the end of an extended leg (*see* page 119 on casting).

If you do feel that an armature is necessary, copper wire is best because it can be left in place when the figure is cast and becomes part of the metal in the statue itself.

A wax sketch (we are considering here figures no larger than 8 or 10 inches in height) makes an ideal scale model, since a 9-inch sketch is actually an eighth-size statue—"life" being considered slightly larger than true life size.

Wax is equally adaptable to the following two basic techniques: (1) the piece you start with gradually is added onto with small coils and pellets of wax modeled into place; or (2) the piece you start with is pinched and stretched to the desired basic form, then individual coils and rolls are added onto it and modeled in.

It is a simple matter to make flat sheets of wax—especially handy in the facture of jewelry—by just melting some wax in the top of a double boiler and pouring it out over a dampened smooth surface like a glass, enamel, or marble table top. The shape of poured sheets can be controlled by forming little dikes out of clay or wood, but never forget that whatever you use must be dampened to keep the wax from sticking to it.

Clean hands keep wax reasonably clean. Never let clay or dust mix into your wax; they will kill its consistency.

Although a wax sketch will keep indefinitely, the best thing about the medium is that something you do that really satisfies you can be cast into metal at a cost no more, if not less, than having a plaster cast made of it.

Recent advances in the field of fine casting by centrifugal machinery must be credited, not to sculptors or foundries, but to dental technicians. The dental process, briefly, is to pour a plaster-like mixture over the object to be cast, leaving a single hole in the cast itself. Through this hole, the wax inside is burned out and hot metal literally is shot in to replace the wax. The hot metal then takes the exact form of the wax by being spun rapidly in a simple centrifuge. During World

War II, improvements in centrifugal casting were made for the mass production of precision parts for armaments.

Very few sculptors do their own casting because of the expense of adequate equipment. If you are serious about wax as a sculptural medium, you should make friends with the centrifugal caster in your area. Your own dentist may be able to recommend one.

If you want to cast a piece that will not fit the equipment available, an arm or other extremity that extends beyond the flask dimensions can be bent at an appropriate joint and, after casting, can be bent back into position by using an acetylene or gas torch to soften the metal at that joint. You can cut a large wax figure or group apart and cast it in sections, silver-soldering it together again afterward.

137—Soften a piece of wax in your hand.

138—Roll it on a dampened surface into

139—an elongated shape.

140—Gently curve the narrow end.

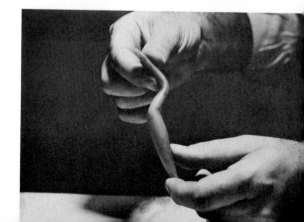

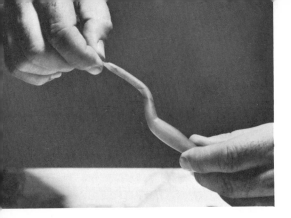

141—Pinch out a delicate beak.

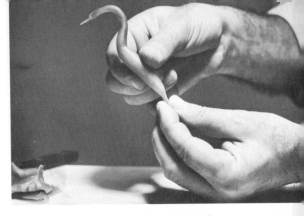

145—Pinch out a flattened tail.

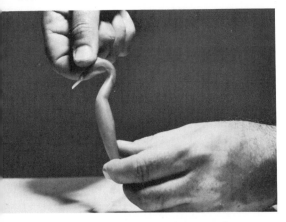

142—Complete the curve of the neck.

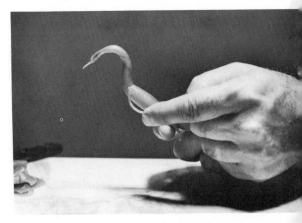

146—Add long, thin, rolled-out pieces

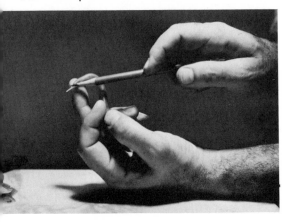

143—With the dampened point of a pencil,

144—indent eye sockets and add eyeballs.

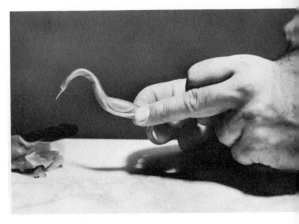

147—to delineate the heron's wings.

148—With pencil point, model tail feathers.

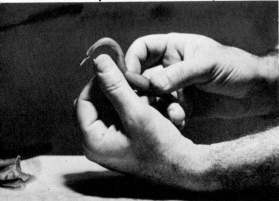

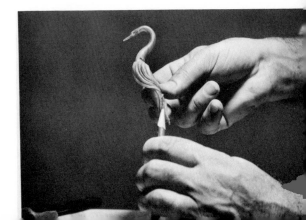

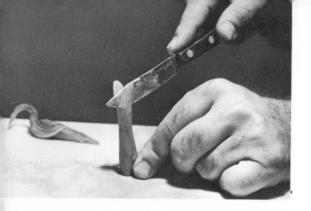

149—Slice into top of stump-shaped piece

150—of wax and twist for wood texture.

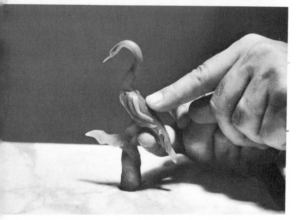

151—Attach bird to limb by pressure.

152—Add another bird for composition—this is all for the birds.

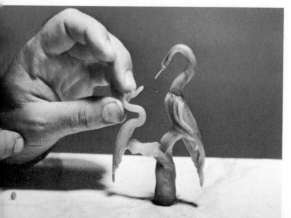

I always go through a lot of doodling before I settle on a new design, first running through things that come easiest to me. Most people repeat familiar designs whenever they doodle. That may not seem very productive of new ideas, but, when you, too, doodle in clay or wax, usually you will first get something that is quite close to what you always do—and then you start experimenting. When you reach the take-off point, that is when designing begins.

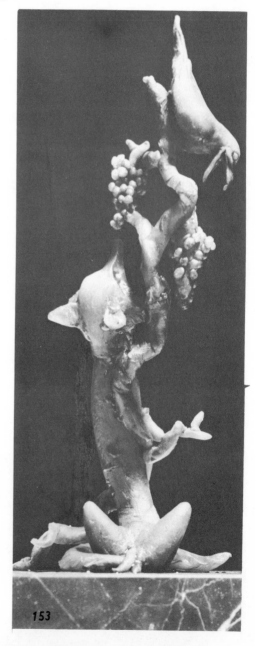

153

FAWN

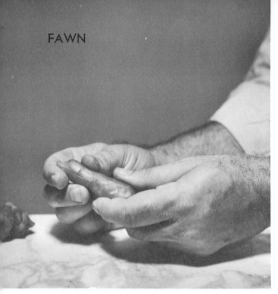

154—With this inanimate piece of soft wax,

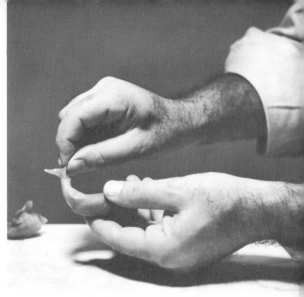

157—Where the head joins the neck,

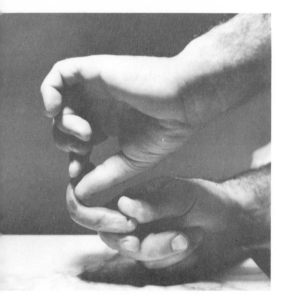

155—start a fawn by bending up the neck.

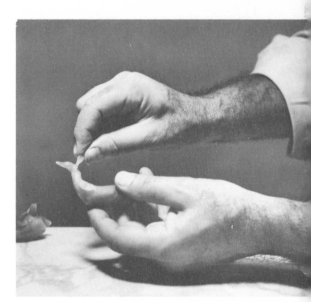

158—pinch out two ears; shape the points.

156—Bend over the end to form the head.

159—Form a tapering muzzle.

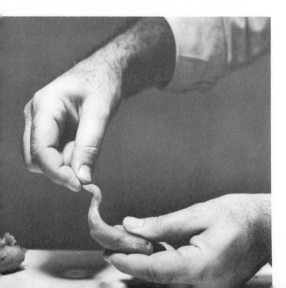

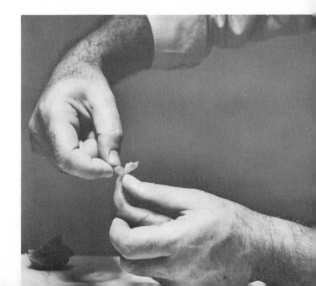

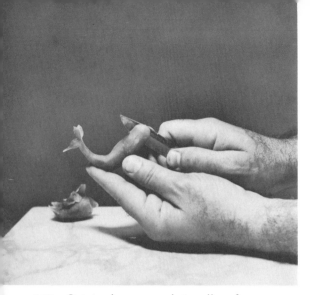

160—Cut in deep enough to allow for legs.

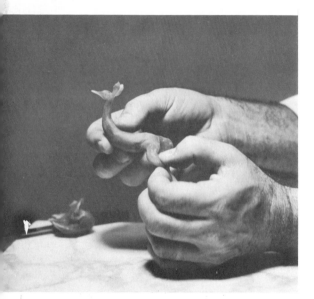

161—Form a lamb chop for upper leg, leaving

162—enough wax to squeeze out lower leg.

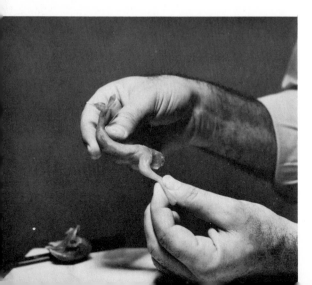

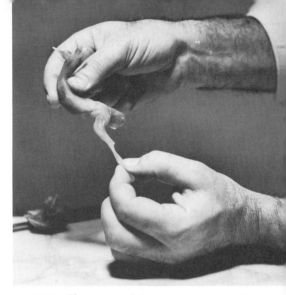

163—The curve of the tingers gives natural

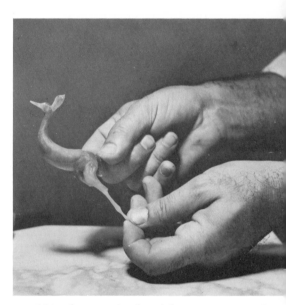

164—shape as heel and foot are squeezed out.

165—Repeat same sequence for other hind leg.

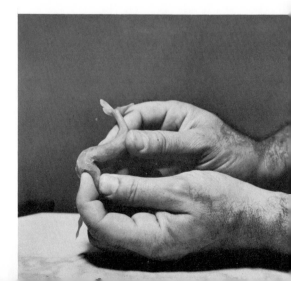

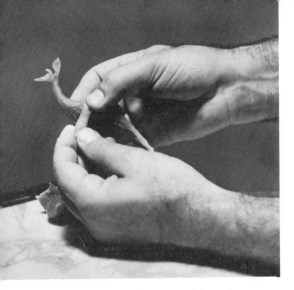

166—Attach piece for forming of front leg.

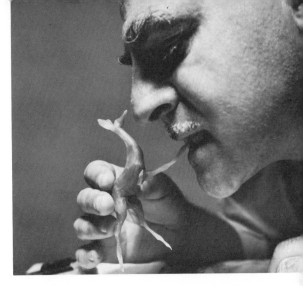

169—For sharp hoofs, bite off surplus wax.

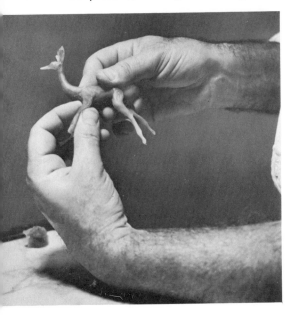

167—Pinch out the tapered parts of the leg,

168—leaving slight thicknesses at joints.

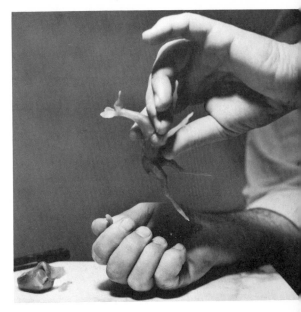

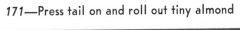

170—Add other front leg and a little tail.

171—Press tail on and roll out tiny almond

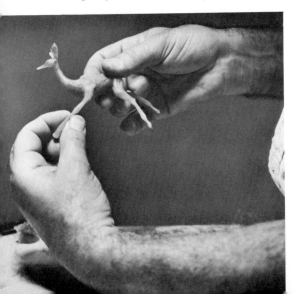

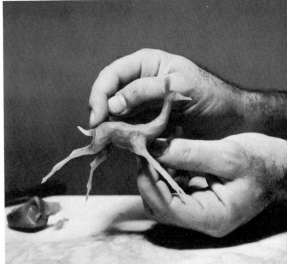

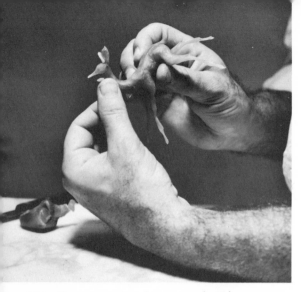

172—the proper size for eye and stick on.

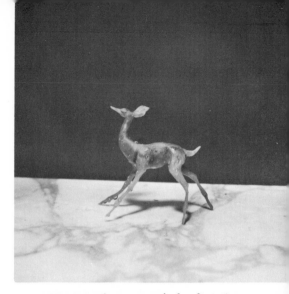

175—it is, figure stands for first time.

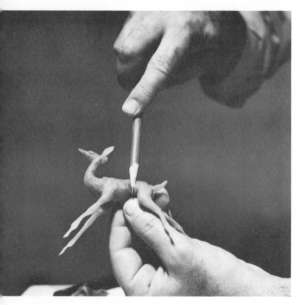

173—Accentuate form where limbs join body.

174—Cold water dip and, like newborn fawn

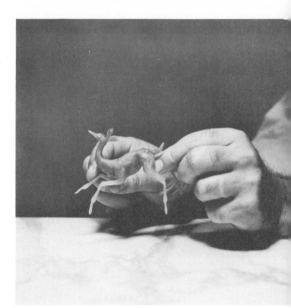

176—For some characteristic poses, remember

177—to bend your figure only at the joints.

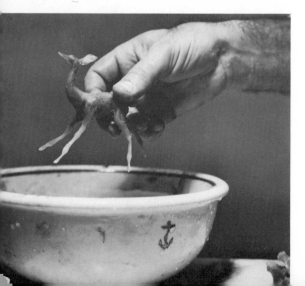

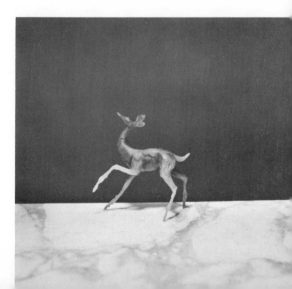

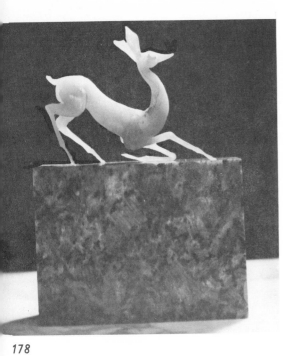

178

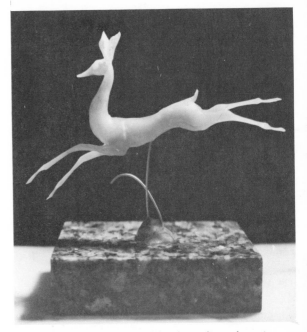

179—A bent wire lifts bounding deer in air.

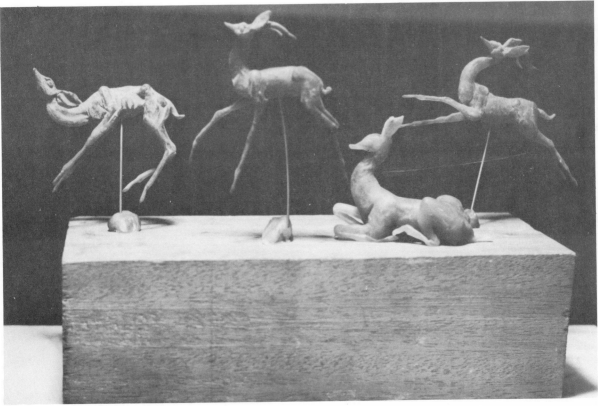

180

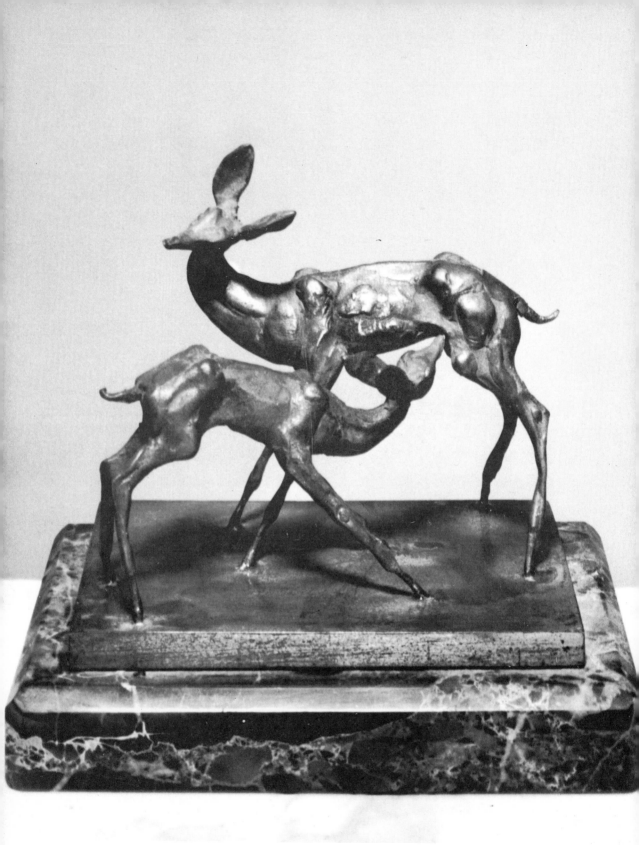

181

182—Make a cut for the legs.

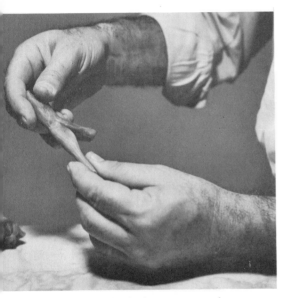

183—Pull down thigh, leaving enough wax for

184—basic forming of the lower legs.

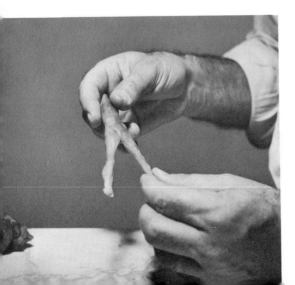

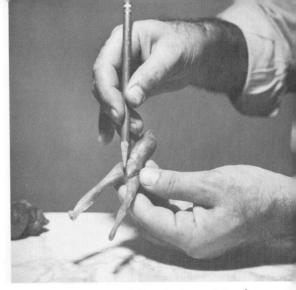

185—Grooves delineate legs at trunk.

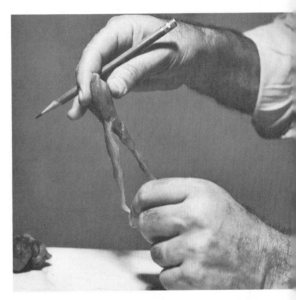

186—Turn up feet.

187—Make a second cut for the arms.

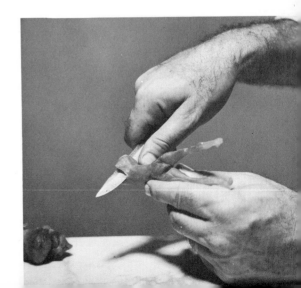

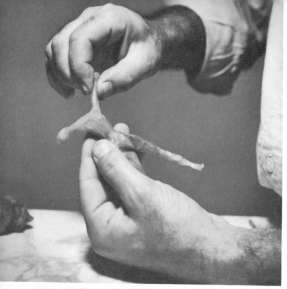

188—Pull out basic form of arms and

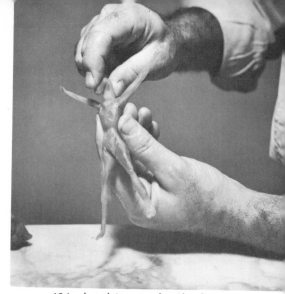

191—bend it over for the face.

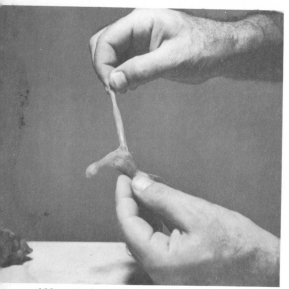

189—pinch out the hands.

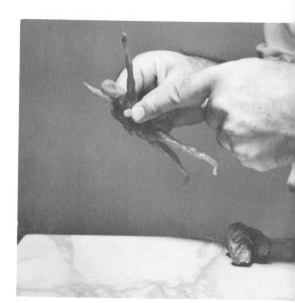

192—Press on simple round balls for breasts

190—Attach piece for head and

193—and add her hair.

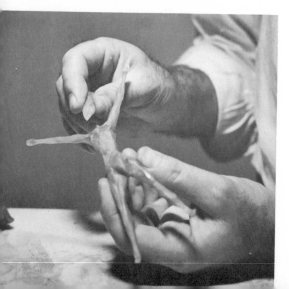

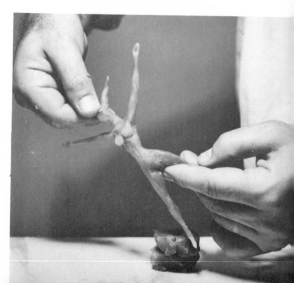

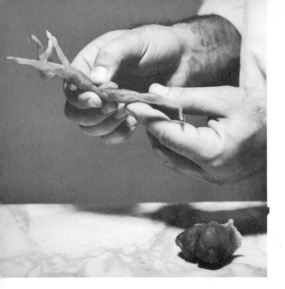

194—Attach her buttocks.

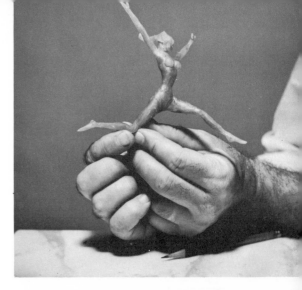

196—to bend her only at the joints.

When changing the position of a figure in wax, it is important that the body be bent only at the joints: to change the position of an arm, bend the wax only at the shoulder, elbow, or wrist. If you try to change the position of a limb by just bending it anywhere along its length, you will wind up with arms and legs that look like rubber hoses. And whenever you do change the direction of an appendage, be careful to press gently either side of the joint. This will preserve the form of the figure as you work.

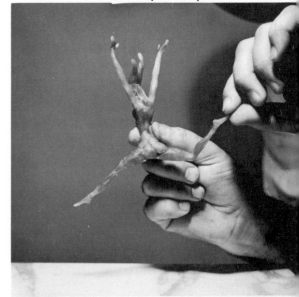

197—Refine your modeling wherever you feel

195—Now put her in motion, being careful

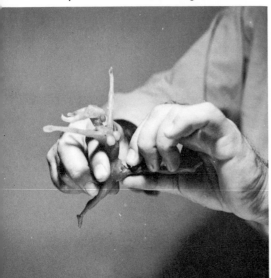

198—she needs it. Incline the head.

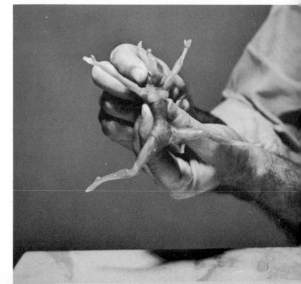

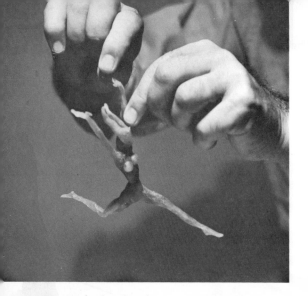

199—Make her hands expressive.

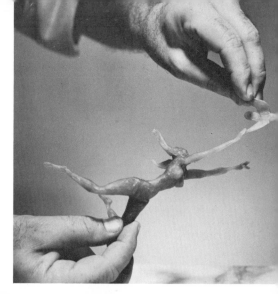

202—in flights of fancy. How about a bird?

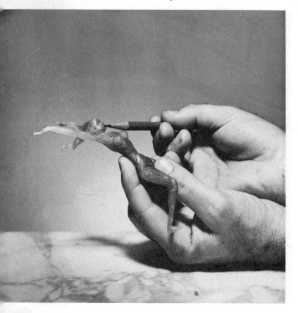

200—Damp pencil point heightens features.

201—Let your imagination soar

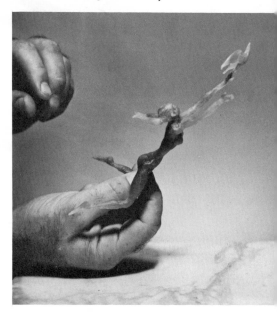

203—And here's a composition.

204—Bring her down to earth,

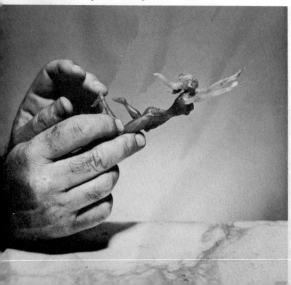

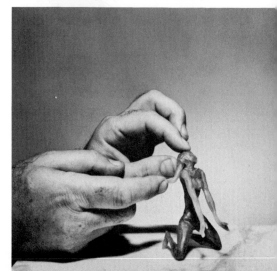

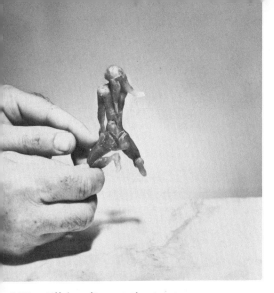

205—still bending at the joints.

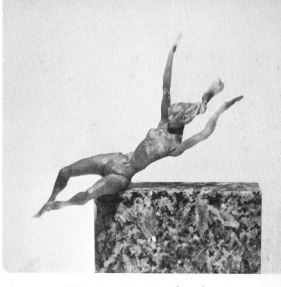

208—Experiment with a base.

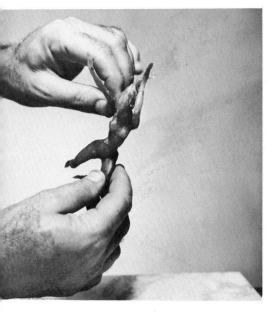

206—Start a new pose and

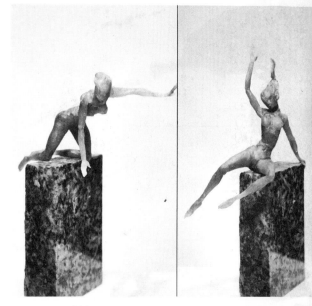

209 210

207—touch up modeling at any point.

211

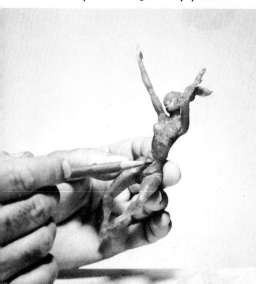

79

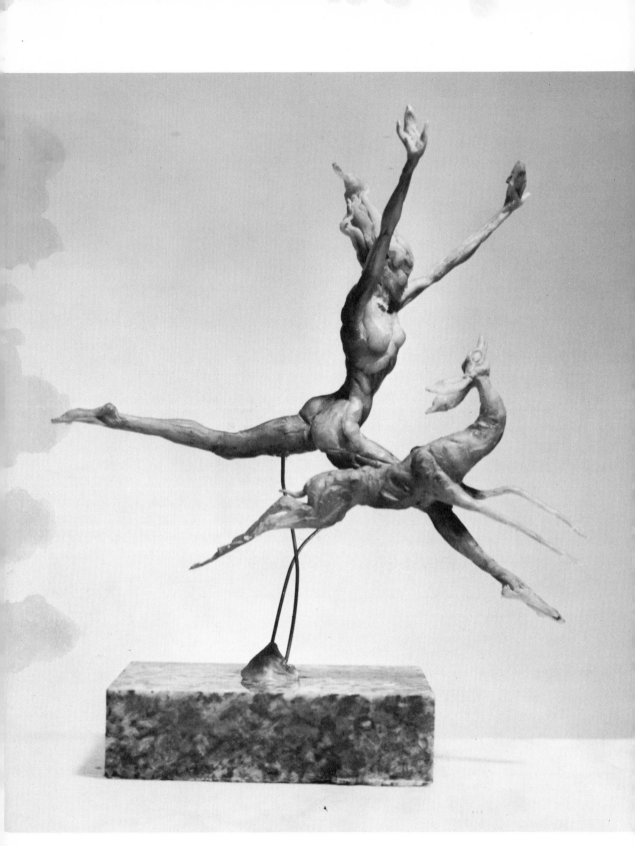

212

COMPOSITION

Diana was goddess of the hunt. The theme of a group built around her is a theme of flight. The main objective, therefore, is to show motion as gracefully as possible. There are numerous subtle ways to do this beyond a mere translation of a deer and a human running. The eye of the onlooker must be caught by certain dynamic lines of action that flow through the group—the arc of the deer and its legs, together with the legs of Diana, must have a horizontal sweep. Her body can arch forward like a diver or backward like a dancer, but straight up she would, of course, be static and uninteresting. There are many alternatives, and, naturally, there is no set formula for any specific bodily action.

You will discover that putting together the parts of a composition is much like putting together the words of a satisfying sentence—when it is "right" the final effect is always greater than the sum of its parts. And when it is right you will know it.

The wonderful thing about working in wax is the ease of expression possible to the artist in the way it can be bent and twisted, stretched and rearranged, or how it can be cut apart and, with heat, easily rejoined. Its inherent strength, moreover, is its ability to stick together by mere compression at very fine points of contact—and, above all, its retention of cleanness of form through any number of changes, as is so clearly illustrated in the various violently different positions of the wax nymph—in her last pose the modeling is just as clean as when she first came to life.

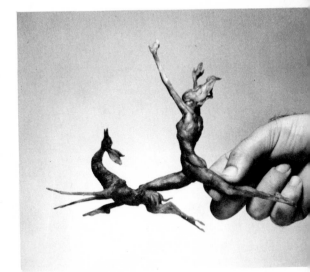

213

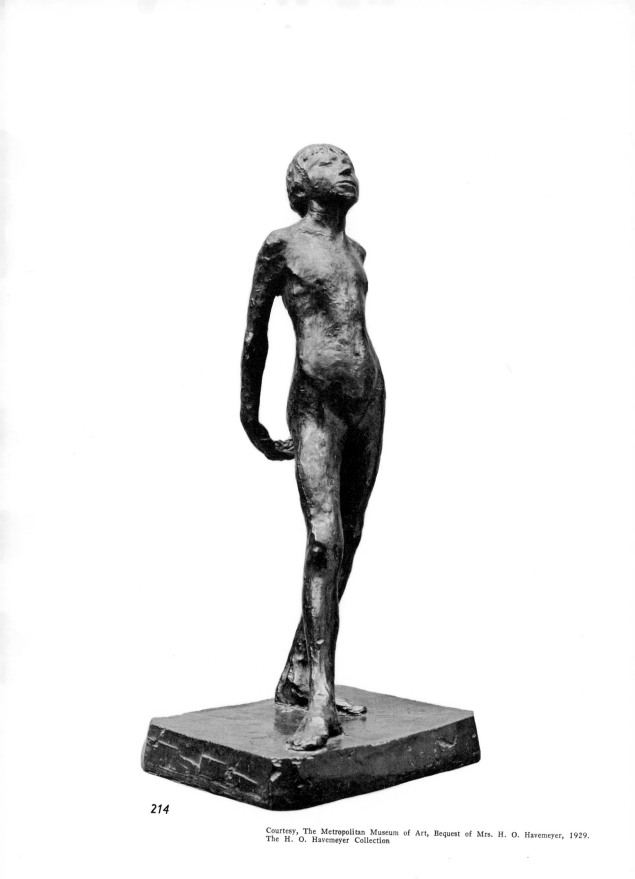

214

Courtesy, The Metropolitan Museum of Art, Bequest of Mrs. H. O. Havemeyer, 1929.
The H. O. Havemeyer Collection

214–230—A PORTFOLIO OF THE DEGAS WAXES. Before he went completely blind in his old age, French impressionist painter Edgar Degas (1834–1917) turned to the facture of small wax sculpture that proved he was not only a great painter but also a sculptor of the first rank. As in his painting, he was interested primarily in the caught moment and the personality bared, with an emphasis on form and a suppression of incidentals. Perpetuating the realism and illusion of the Baroque, Degas' waxes (shown cast in bronze on the facing page and on the next ten pages) shoved aside accepted notions of sculpture as cold, immaculate, and white. Although they left the public quite confused when first shown, an art critic of the times, J. K. Huysmans (*L'Art Moderne, l'Exposition des Independants*, 1881), called the Degas waxes ". . . the one real attempt to create a language for modern sculpture known to me today." Explained Degas: ". . . to express everything that can bedevil reality—that is the art which it is our duty to practice."

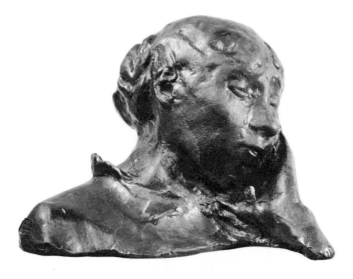

215

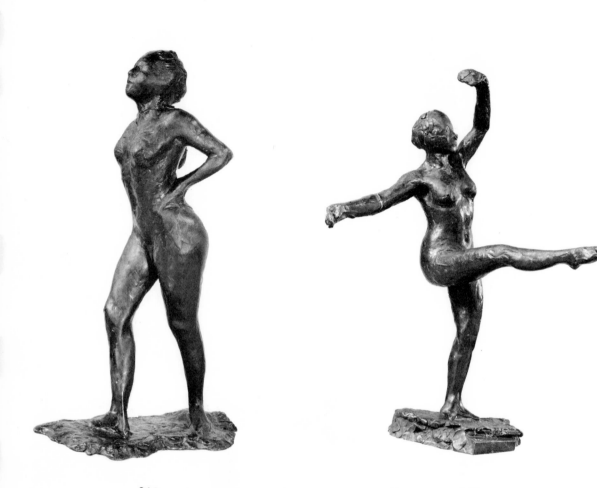

216 217

Courtesy, The Metropolitan Museum of Art, Bequest of Mrs. H. O. Havemeyer, 1929.
The H. O. Havemeyer Collection

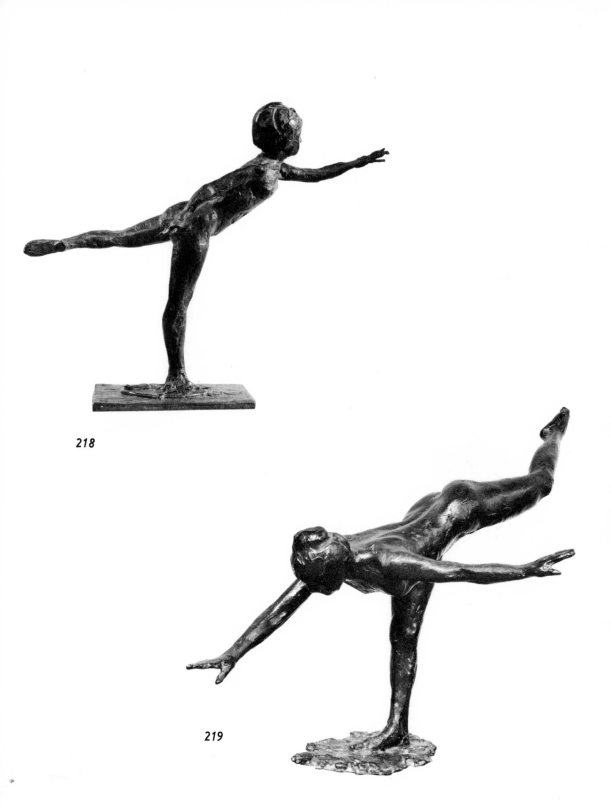

218

219

Courtesy, The Metropolitan Museum of Art, Bequest of Mrs. H. O. Havemeyer, 1929.
The H. O. Havemeyer Collection

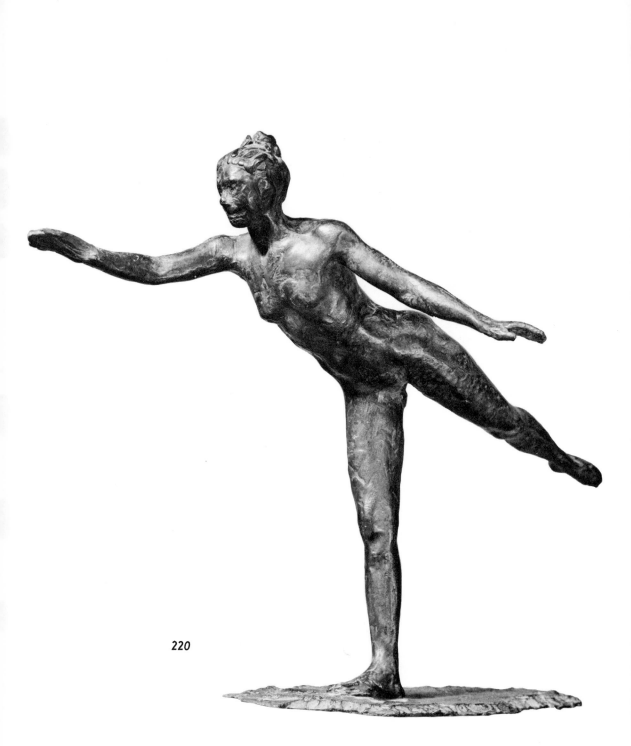

220

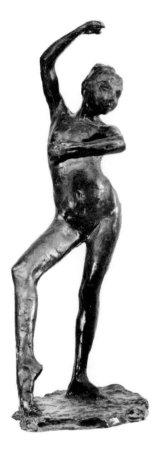

221

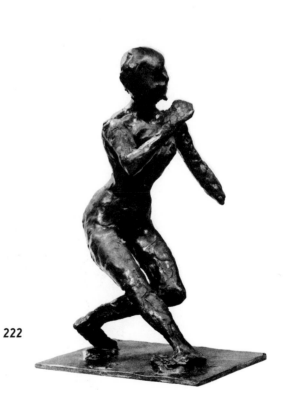

222

Courtesy, The Metropolitan Museum of Art, Bequest of Mrs. H. O. Havemeyer, 1929.
The H. O. Havemeyer Collection

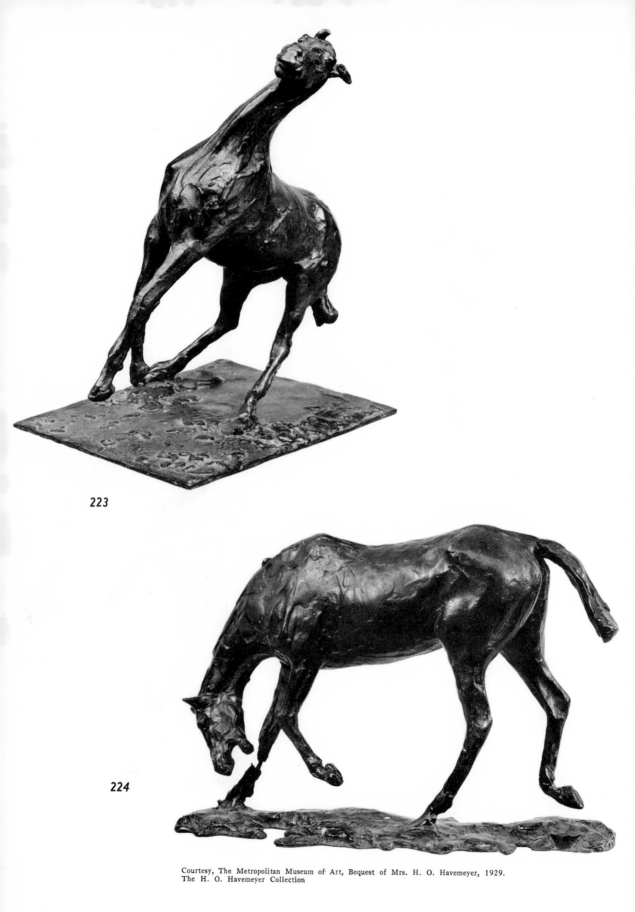

223

224

Courtesy, The Metropolitan Museum of Art, Bequest of Mrs. H. O. Havemeyer, 1929.
The H. O. Havemeyer Collection

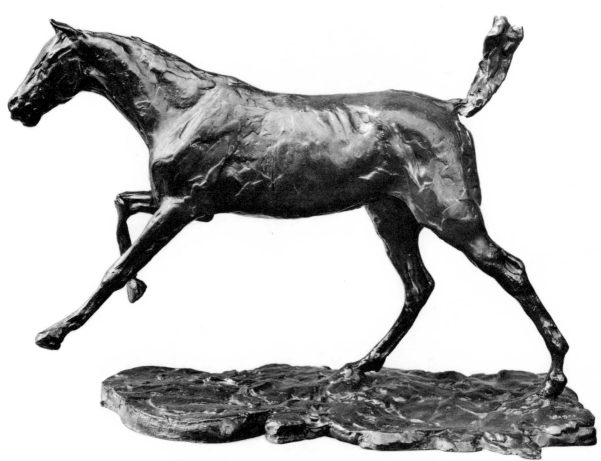

225

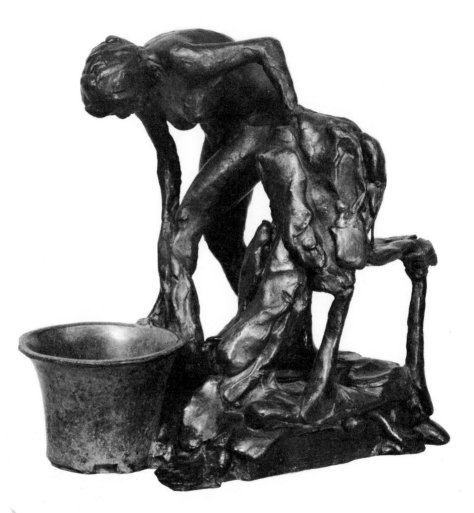

226

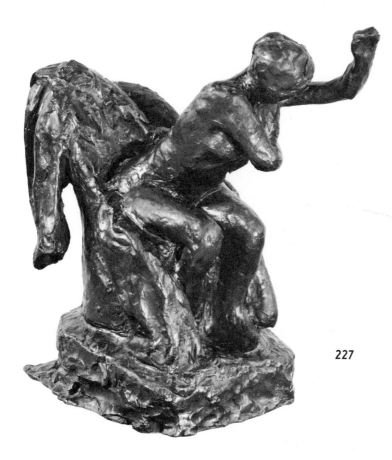

227

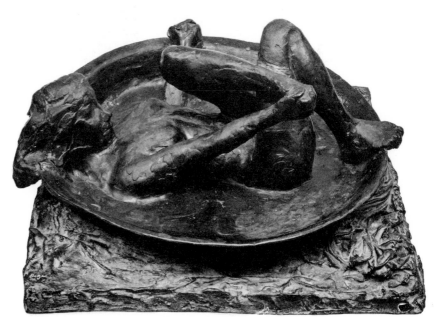

228

Courtesy, The Metropolitan Museum of Art, Bequest of Mrs. H. O. Havemeyer, 1929.
The H. O. Havemeyer Collection

91

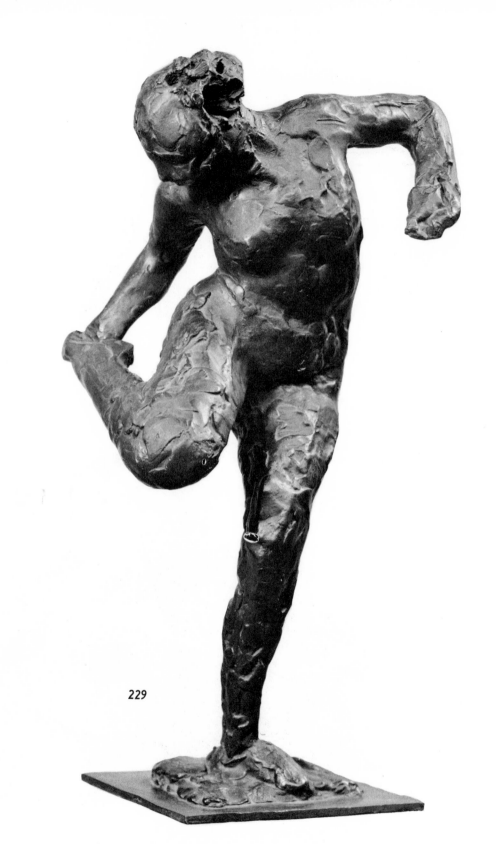

229

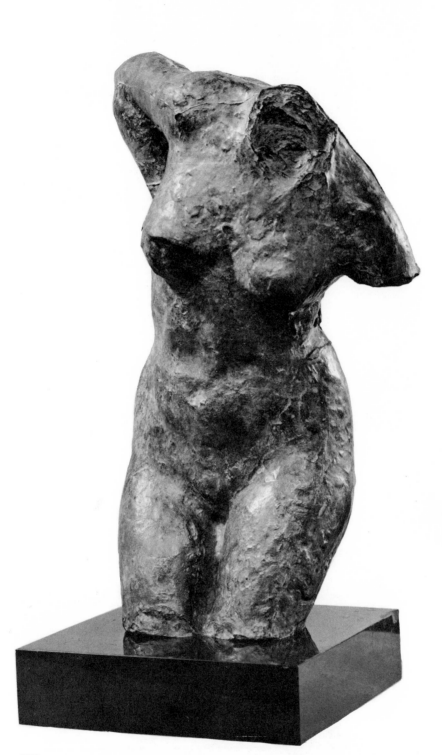

230

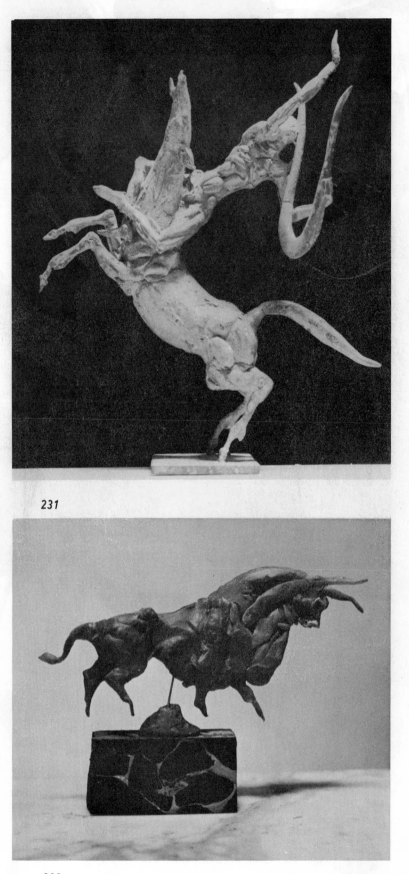

231

232

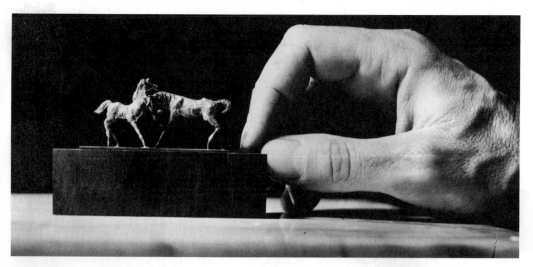

233

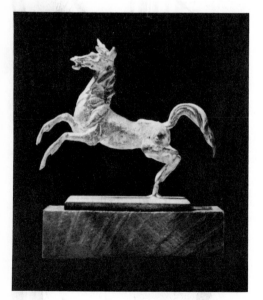

234

231–234—Facing page: Miniature sculpture by the author is only a few inches high; the horse and rider have been cast in bronze and given a green patina, while the bull, still in wax, is ready for the caster. Above and left: Subminiature sculpture by the author demonstrates the fineness of detail possible in wax that has been centrifugally cast.

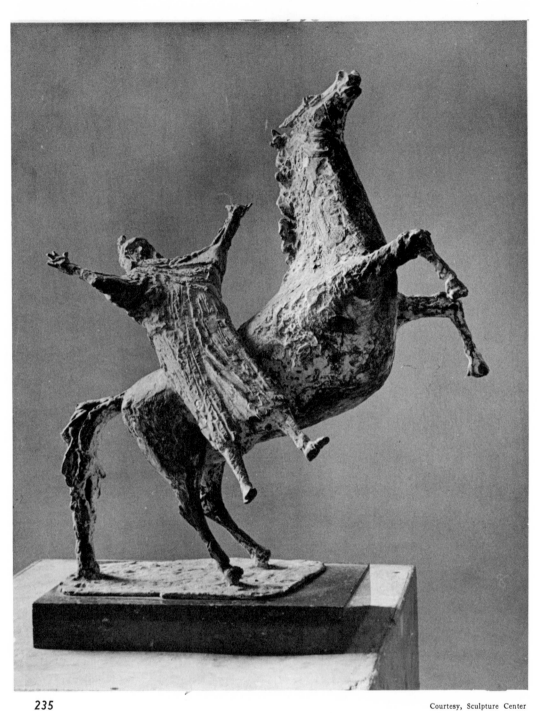

235

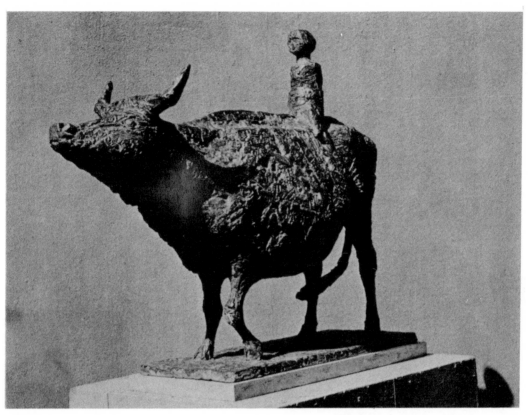

236

235-236—An expressive texturing is illustrated in contemporary sculptor Sahl Swarz's "Ox and Boy" above, and in his "Conversion of Saul" on the facing page. Both are bronze cast from wax.

97

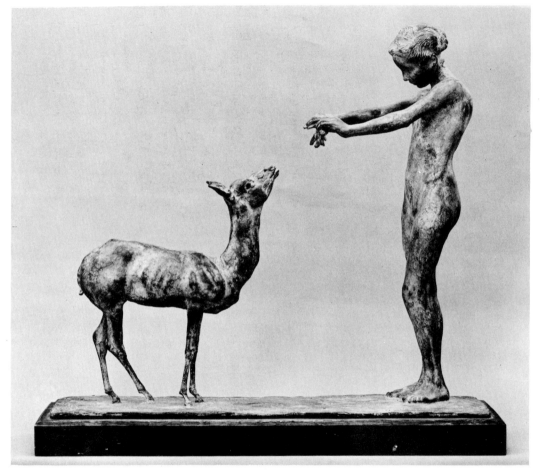

237

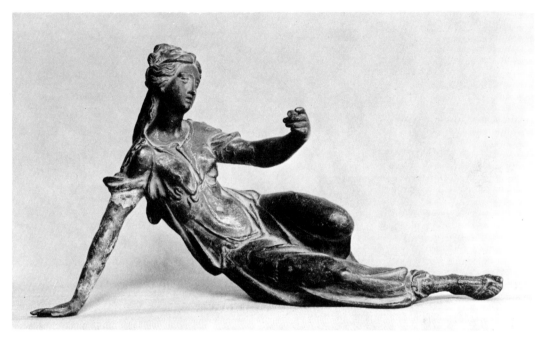

238

237–238—Contemporary French sculptor Henri Bouchard's young girl and gazelle on the facing page bears much of the charm and grace found in the sixteenth-century Florentine School, Omphale, statuette above. Both demonstrate the delicate form and finish the medium of wax (cast in bronze) is capable of in the hands of the experienced sculptor.

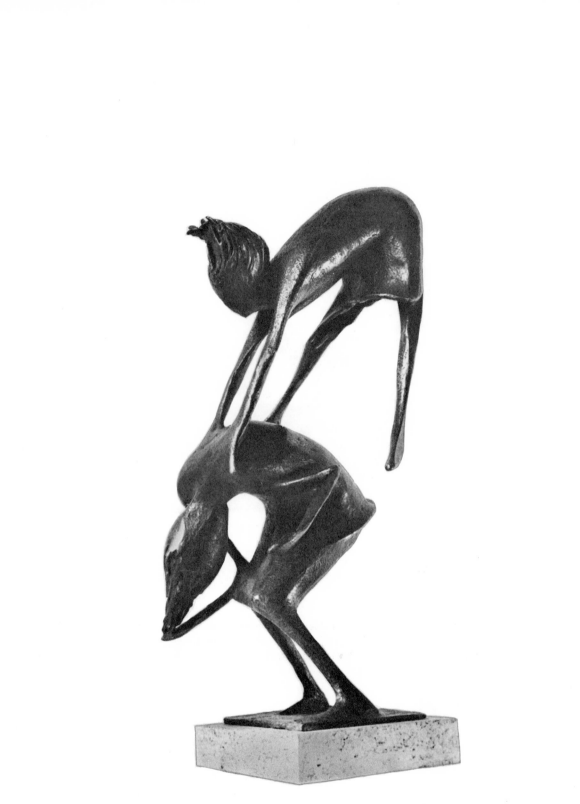

239

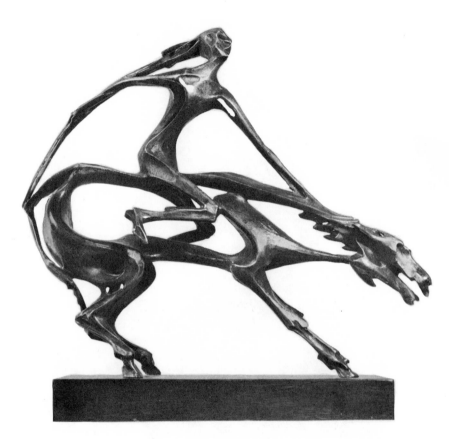

240

239–240—Robert Cook's contemporary "Mounted Indian," 8", makes use of still another approach to wax in which the negative spaces become as important as the area actually occupied by mass. On the facing page, Cook's "Leapfrog" is a veritable tour de force of the balance of form obtainable in wax cast into bronze.

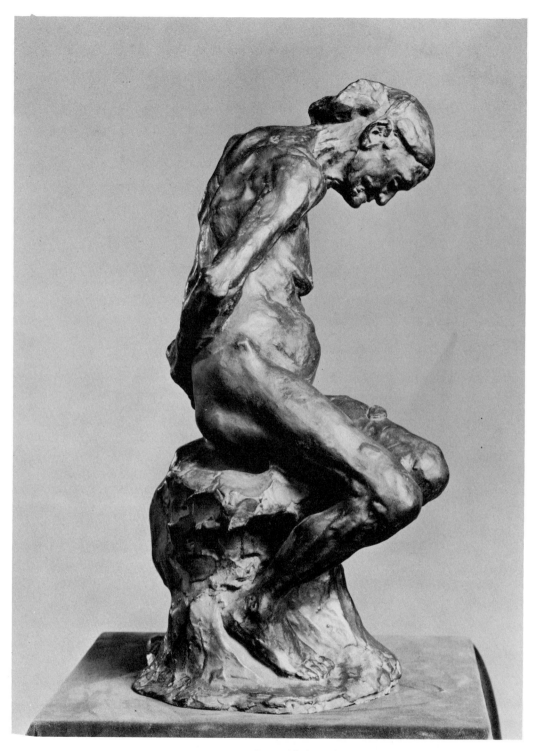

241—"The Old Courtesan" by the French, nineteenth-century sculptor Auguste Rodin is a statuette that may have been intended as a sketch for a full-scale statue. Done in wax, it is cast in bronze.

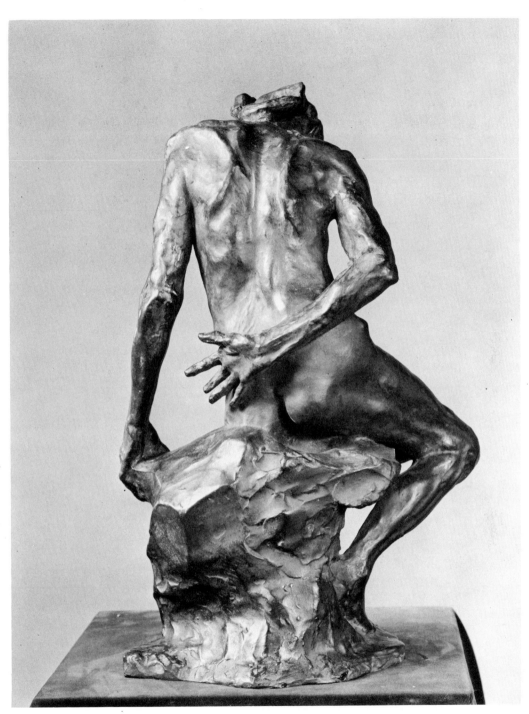

242—Back view of the same statuette displays an interesting subordination of detail to concentrate attention on the expressive hand—although the subtle texturing of the skin of the back clearly typifies age.

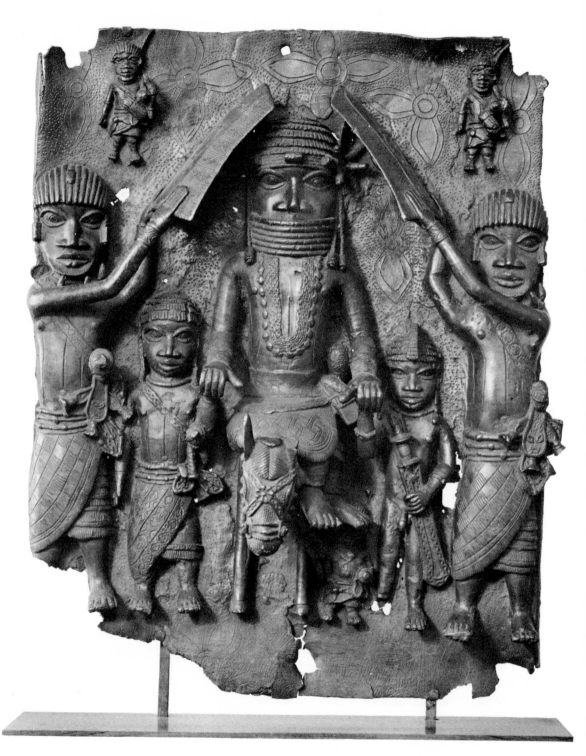

243

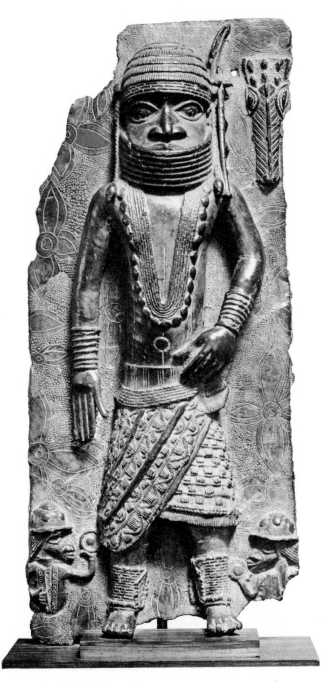

244

243–244—Probably done in the sixteenth or seventeenth century are these two African plaques, made in wax and cast in bronze, from the kingdom of Benin in Nigeria. The one on the facing page represents a king and his attendants, the one above a royal personage. Though popularly called "primitive art," the cultures that produced these magnificent sculptures reached a remarkably high degree of proficiency in the technology of lost-wax casting.

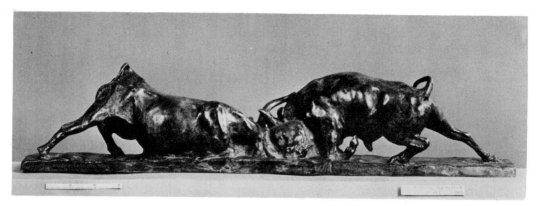

245

Courtesy, The Metropolitan Museum of Art, Rogers·Fund, 1907

245-246—"Bulls Fighting" is a small bronze of violent force by modern sculptor S. H. Borglum. Below: Phillip Noteriani's "Come Hither," 4″ high, done in 1956, makes use of a natural stone base to give the statue an added sense of reality.

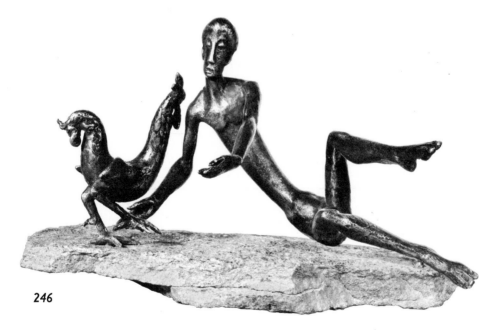

246

Courtesy, Sculpture Center

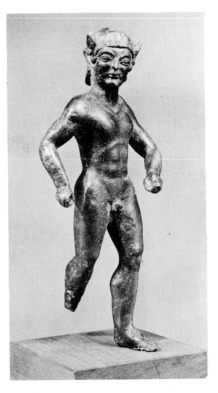

247—Fifth-century B.C. Etruscan statuette represents a warrior setting out for battle.

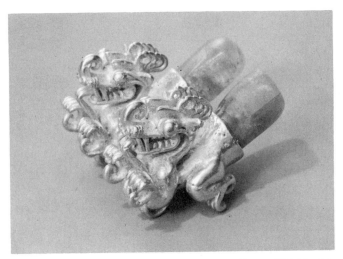

248—Objects carved or modeled in wax are cast into many metals; this fourteenth- or fifteenth-century gold pendant, 1½" high, was unearthed in Panama. The two heavy protrusions are quartz.

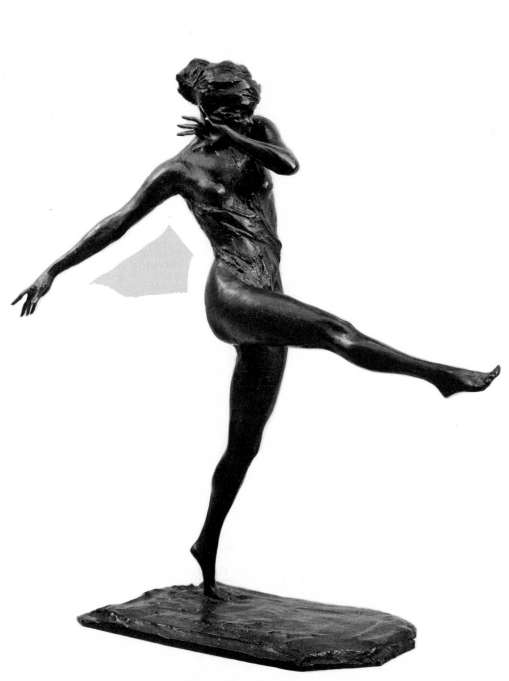

249—Dancing girl cast in bronze from wax is by Russian sculptor Prince Paul Troubetzkoy, 1866–1938.

108

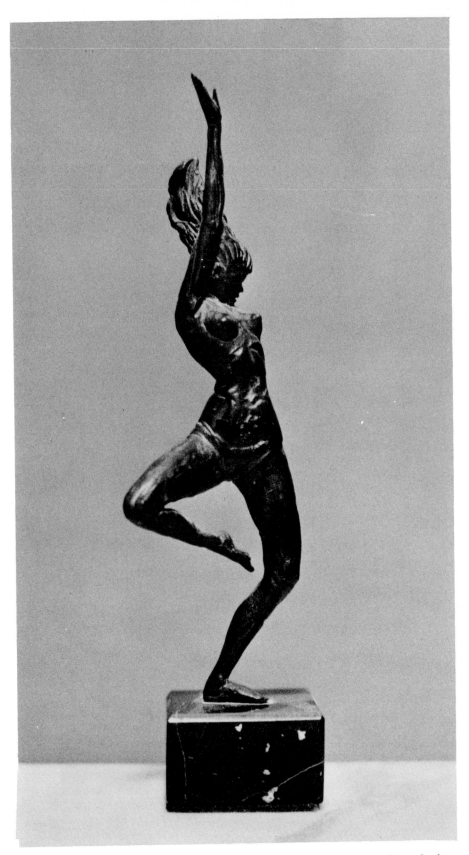

250—Dancing girl by the author, also bronze cast from wax, is only 6″ high.

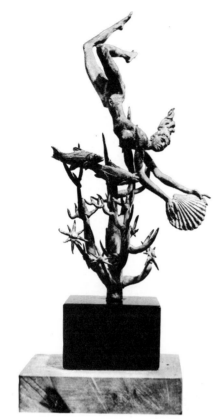

251

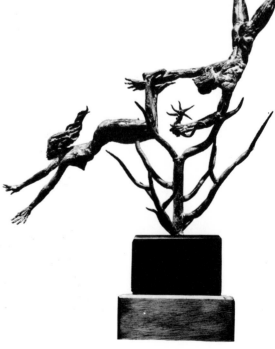

252

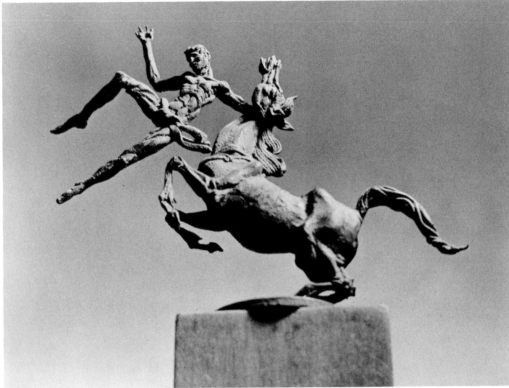

253

251–253—In each of these small bronzes by the author, none of which is over 8″ in height, the suspended human figures have been centrifugally cast separately, then attached to the rest of the statue by the ordinary silver-soldering method. In this way, a small centrifuge may be used to cast fairly complicated pieces.

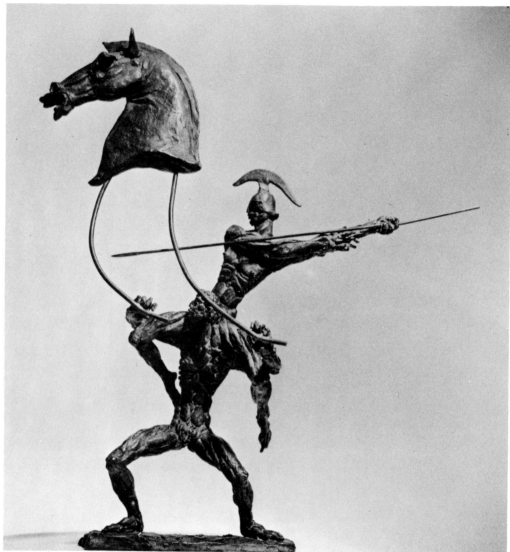

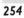

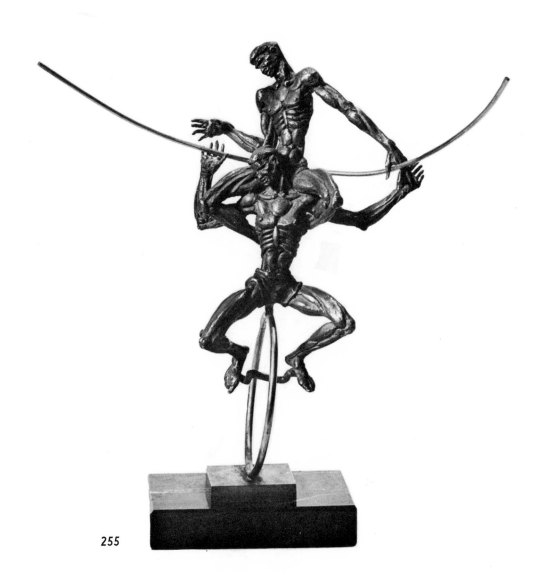

255

254–255—By casting parts separately and soldering them together afterward, interesting balance and counterbalance is possible in bronze statuary cast from wax. On the facing page, the author's 10" "Trojan Horse"; above, the author's 12" "Unicyclists." Note how, in these sketches, various muscles and tendons, laid on as simple coils with little additional modeling, serve to accentuate the tension.

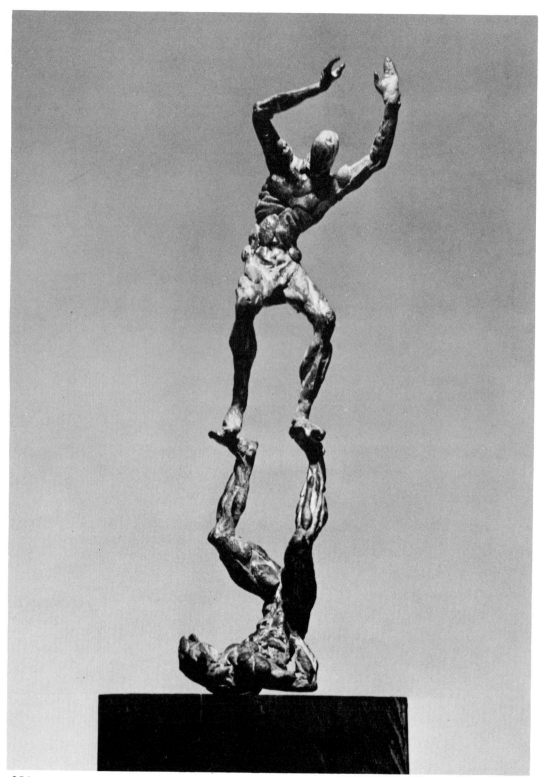

256

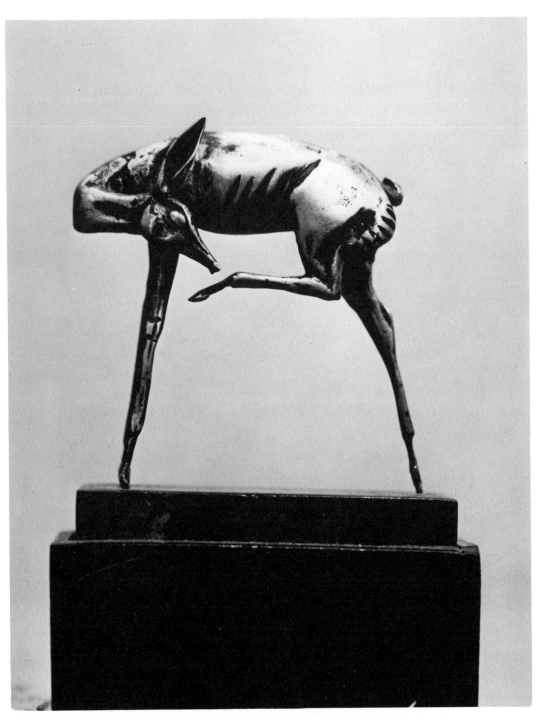

257

256–257—The stylization of form in this 4″ fawn is accentuated by a dark patina that the author has burnished off the high parts. Facing page: In this 8″ sketch by the author, the acrobats were cast separately and joined later at the feet.

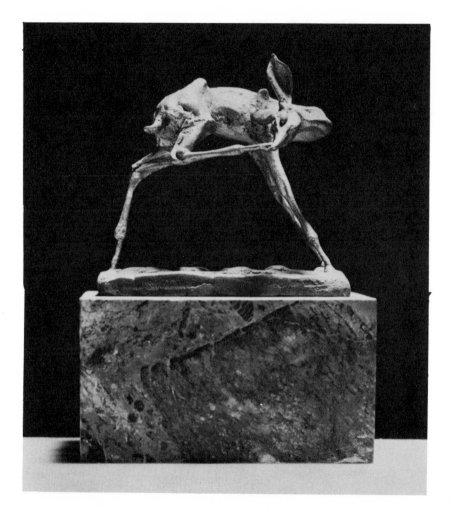

258—The author has given this more realistic version of a fawn a patina of gold.

CASTING

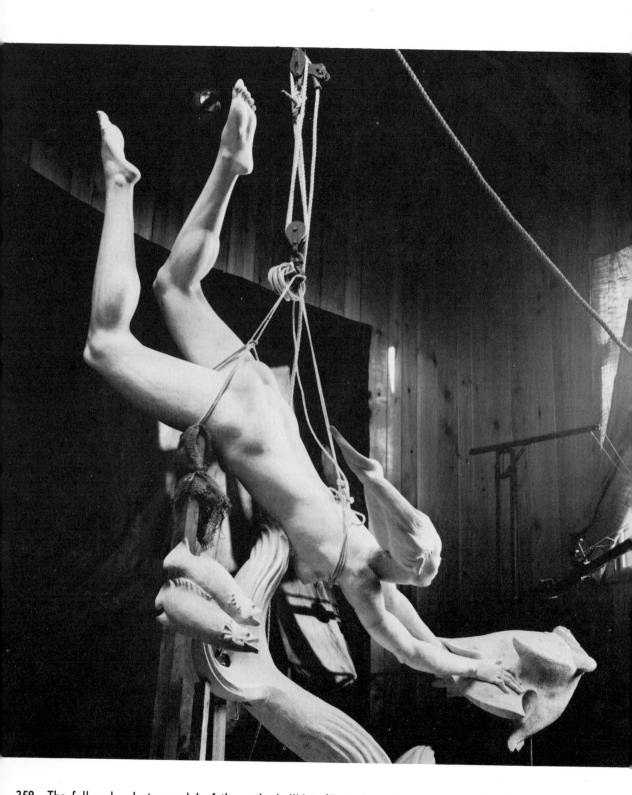

259—The full-scale plaster model of the author's "Naiad" starts on its way to the foundry to be cast in bron

A basic understanding of casting is a valuable aid to a person studying modeling. Casting is a purely technical matter about which a number of good books have been written; what follows is intended merely to give you a vocabulary for working with a casting foundry, in case you reach the point where you want to transpose a finished work into a permanent medium like bronze. It is not intended as a technical exposition, but simply a brief description of how casting is done.

The most common, least expensive, and easiest material to work with in casting a clay statue into a more permanent medium is plaster of Paris. Almost every piece of sculpture, except fired ceramic and those which are cast from wax, is made into plaster before being transposed into its final medium—bronze, cast stone, or marble. The same plaster model, once you have it, can serve for transposing sculpture into any or all of these media.

Today's professional sculptor usually does not take the time to make his own plaster of Paris casts. There are artisans who specialize in this. But it is important for the sculptor to know about the craft itself so that he can discuss intelligently with his caster any problems that arise—such as where best to divide the cast to keep the seams in the mold from interfering with the modeling.

It is important to be acquainted with the techniques of casting, because in certain ways specific structural problems will dictate various alternatives in the design of your statue. For instance, internal iron pipe bracing may be needed, for which allowances must be made in the form—this would be vital in a figure of a rearing horse.

Here then, in simple terms, is what happens in the evolution of a statue from clay to bronze.

First, a plaster of Paris mold is made of the completed clay statue, and this may be anything from a simple two-piece mold for a head to an elaborate multipiece mold for a complicated figure or a group.

The mold is divided into sections by the insertion right in the clay of small, thin rectangles of brass called "shims." The shims form walls that differentiate the sections of the mold when the plaster is laid on. The plaster of Paris,

260

mixed to a thick, creamy consistency, is coated over the entire statue if it is a small one, but is coated on section by section if the piece is very large. As the plaster gets harder, it is spread on with a spatula until the statue is completely enclosed like a mummy. Within half an hour, the plaster is hard and is then gently wedged apart at the joints formed by the walls of shims.

Then the inside of the plaster mold is washed out, and an imperceptibly thin coating of grease or soap, in some form or other, is applied over the entire inner surface. Next all the parts of the mold are put together, providing at this point, in effect, a negative

of the statue. At the bottom is the opening, so the mold is turned upside down. A new batch of plaster is mixed, poured into the mold, and allowed to set. When it is hard, this is the "cast" from which the outer plaster mold shatters away because of the coating of grease. Great care should be taken, however, that protuberances like fingers, ears, and noses are not knocked off. This mold that has broken away is called a "waste mold," because it is destroyed.

261

At this point you now have a plaster "model" which is sanded and rasped and generally cleaned up.

A bronze casting is done right from this plaster model.

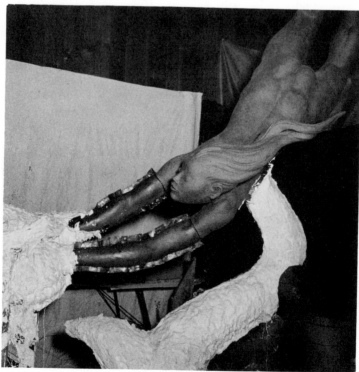

262

THE BRONZE FOUNDRY

At this stage in the evolution of a statue, the sculptor entrusts the plaster model to a man specializing in casting who will reproduce a true and faithful facsimile of the work.

A bronze founder, however, is much more than a reproducer of form. Rudier, Auguste Rodin's founder in Paris, became famous because his bronzes were so much more than just copies of Rodin's art. The founder is responsible, for example, for the final color of the surface of the bronze, which is called the "patina" or "patine." There are literally hundreds of variations of color that can be achieved

263

in the patina. In fact, the raw bronze is a frightening sight to the sculptor as his statue emerges warm from the founder's mold and before it gets its patina.

What actually takes place at the foundry? The plaster model in the hands of the founder will be cast in one of two methods: the lost-wax (*cire-perdue*) process or French sand. Lost wax, a very ancient process, reached its greatest heights in Renaissance Italy in the work of the great Florentine,

Benvenuto Cellini. It is used for the more complicated shapes; French sand casting is used for larger, simpler areas that have a minimum of undercutting, as in bas-relief.

In casting via the lost-wax process, the model of your statue is once again reproduced, this time in wax—but wax no thicker than the bronze of the hollow statue to come, and that is usually no thicker than a quarter of an inch. To achieve this, a mold of your plaster model is made in gelatin. A jacket of plaster holds the gelatin firm. The mold is cut into sections, and hot wax is brushed into its various parts and built up to the desired thickness. When it is hard, the wax matrix is removed from the mold and assembled.

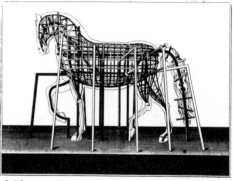

264

Inside it, a core of "investment" (fire-resistant material such as a mixture of ground asbestos and plaster) is poured.

Now on the outside of the wax statue are attached, at critical points, the ends of long, supple, thin rods of wax. The free ends of these "gates" are all bent around and brought together along one central channel called the "sprue," through which the molten metal will enter the mold. The wax matrix of your model is next encased in investment, and only the

sprue is left open in this mass of plaster-like material. The whole thing is then put into an oven—in Italy, since ancient times, a hole in the ground with a fire in it has served as the oven. The statue is turned so the sprue is at the bottom, and the heat melts the wax inside, which runs down through the channels in the investment and out the sprue itself.

This, incidentally, is the point in the process from which the name "lost wax" originated.

After the burnout, the statue is turned back up again and molten bronze is poured into the sprue, run-

left a thin bronze shell of the original plaster cast, but with tiny bronze rods sticking out all over it where the gates were attached. These are cut away.

The process of finishing, called "chasing," consists of tooling the entire surface of the bronze with little chisels and files.

When the chasing is completed and the modeling faithfully returned to the surface of the bronze, the extremely important last stage of patination is done by expert artisans. The patina of bronze is obtained by the use of acids, either with the heat of a blowtorch or without, to produce ef-

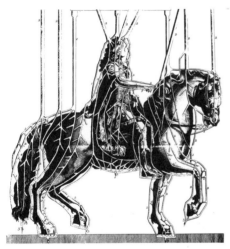

265

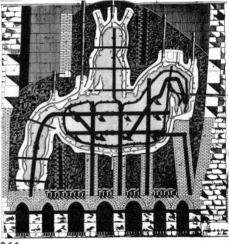

266

ning through it into the gates and vents, filling all the area where the wax matrix existed.

Since this is only a general view of the process, we must overlook such technicalities as the necessary extra gates, or "vents," for escaping gases and the bronze tie rods that have to be inserted to keep the core and outer investment molds separated when the wax is burned out.

When the bronze has cooled and the investment is removed, there is

fects of aging and weathering or to get special colorations. The patina can make or break your statue.

The base upon which a statue rests can be compared to the frame for a painting. A good statue can stand on its own without a base, but it never looks as good as it does with the right base, which can give it a finished look. For bronze, a fine marble or beautifully grained hardwood provides the ideal complement for the sculptor's work.

This briefly outlines the separate areas of responsibility for the sculptor and the founder, one obviously very dependent on the other.

CAST JEWELRY

Models for jewelry today generally are made in wax and cast by the lost-wax centrifugal process. Wax worked thin enough to see through, as shown here, results in very lightweight jewelry of great fineness and detail. For instance, a number of birds made this way can be joined to one another by simply pressing the wax together where the flat surfaces meet. The wings, of course, can be formed to represent any stage of flight.

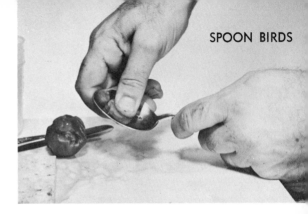

268—Press wax into moistened spoon.

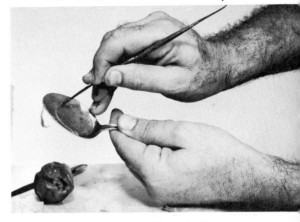

269—Enscribe an ellipse in the wax.

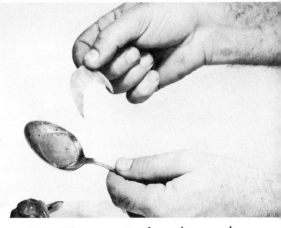

270—Wax separates from dampened spoon.

271—Roll out cigar shape for bird's body.

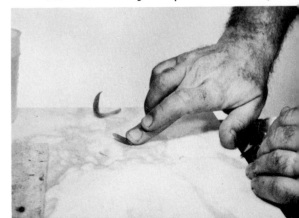

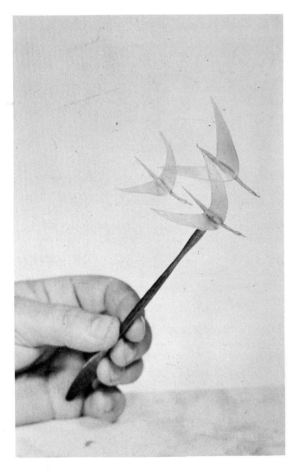

267

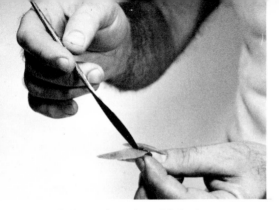

272—With heated tool, weld body to wings.

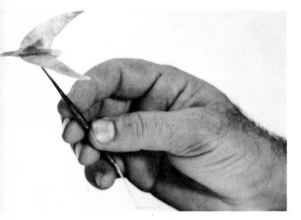

273—Pinch the forward end to form a beak.

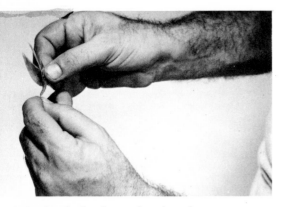

274—And here is your completed bird.

275—Variation: Roll out wax on wet surface.

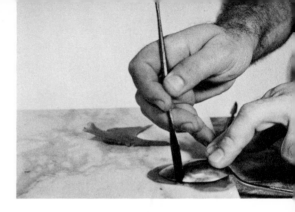

276—Spoon edge is pattern for wings.

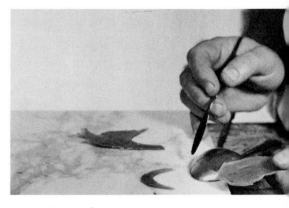

277—Make as many wings as necessary.

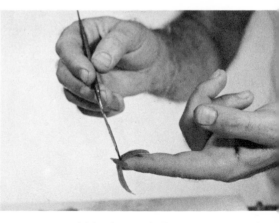

278—Add bodies as before with hot tool.

279—This way you can make a flock of birds.

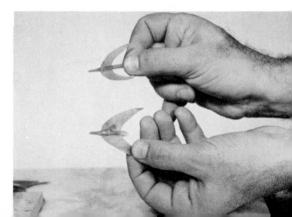

124

CENTRIFUGAL CASTING

281—As demonstrated by Earl Krentzin, the making of a silver clown bottle begins with a model built up out of modeling wax. The heat of a flame is used in sculpturing the wax.

282—The figure should be completed in this state in the exact form and surface texture desired. Aside from the trimming of the gates and buffing of the surface, little more finishing will be needed after casting.

283—Too large to be cast in one piece, this model is cut into sections with a heated knife. A sufficient number of wax "wires" are connected to it to permit a good flow of molten silver from crucible to mold. First section is attached to gate former.

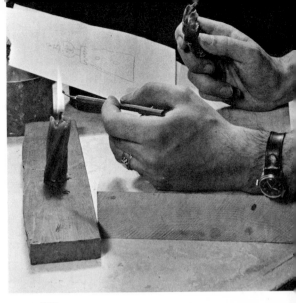

281

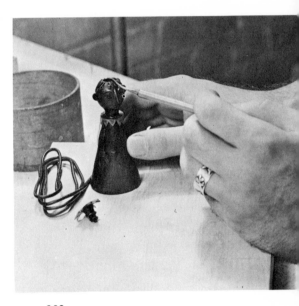

282

283

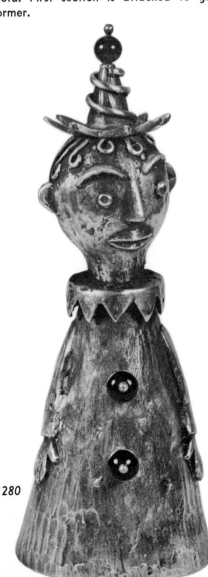

280

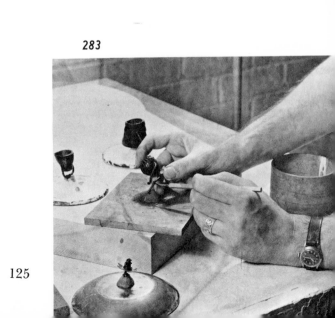

284

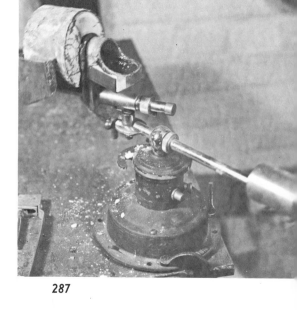

287

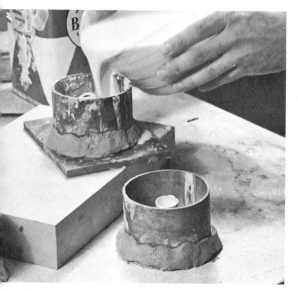

285

286

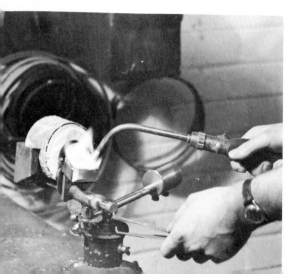

284—Having previously been mixed to a consistency of heavy cream, the first coat of investment is thoroughly and carefully painted on. Great care must be taken to avoid the forming of any air bubbles.

285—The proper-sized flask is then sealed with plasticine to the gate former, which acts as a temporary flask bottom. As it is filled with investment, the flask is tapped to drive out bubbles that may have formed.

286—Plasticine and gate former removed, wax is first burned out in a furnace heated to 1,200 degrees, then the pink-hot flask is placed in wound-up casting machine and the predetermined amount of silver needed is melted with a blowtorch.

287—When the silver is molten, the casting is made by releasing tension on the machine. As it spins, the metal shoots from the crucible into the flask, filling every interstice by tremendous centrifugal force.

288—(A metal safety barrier around the machine was removed for photography.) Investment has been dissolved in cold water. Sprues are then cut from the casting and the rough spots are buffed off.

289—The cleaned and pickled parts are finally assembled by silver-soldering them together. The piece is pickled again and excess solder removed. Oxidized with liver of sulfur, the little bottle is complete.

126

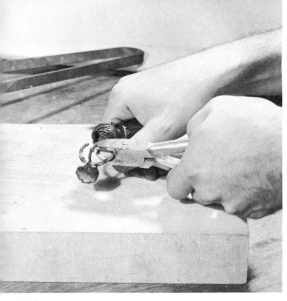

288

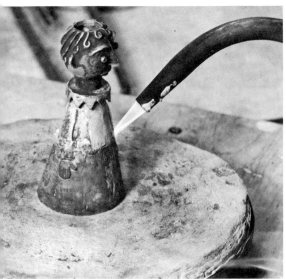

289

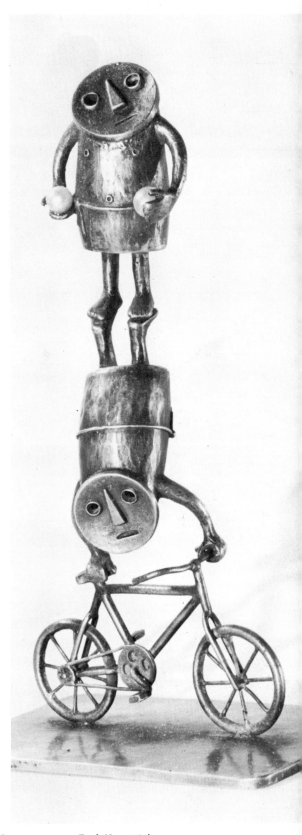

290—Centrifugally cast in silver from wax are Earl Krentzin's amusing acrobats.

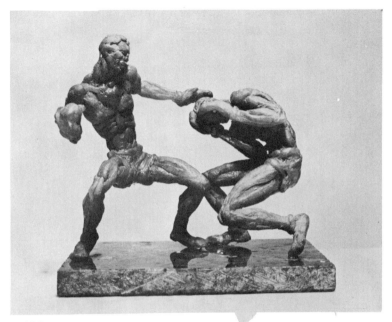

291

291–292—Variations on a theme by the author: The boxers above in wax before casting; those below in bronze after casting.

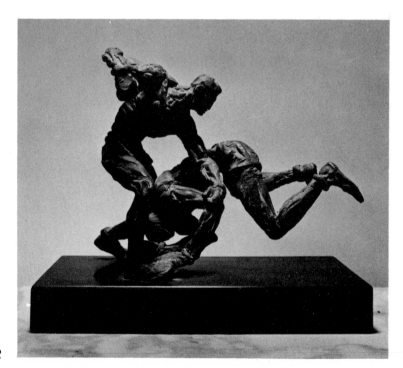

292

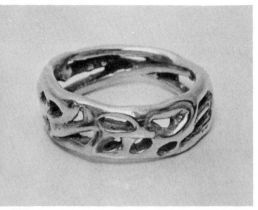

293

Courtesy, Tommy Yee

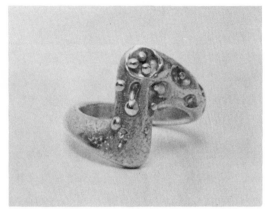

294

Courtesy, Tommy Yee

293-296—Contemporary New York goldsmith Irena Brynner makes her jewelry in wax and casts it in gold by the centrifugal method. The band of the necklace below left, however, was hammered out of gold and joined to the cast element later. Miss Brynner uses a hot-tool technique; the interstices in the ring above left, for instance, were made with a small, hot, spatula-like instrument in a flat sheet of wax, which was then joined end to end and cast. Centrifugal casting is so accurate today that little finishing is required.

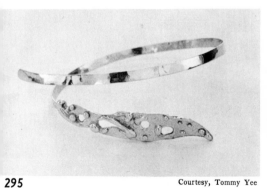

295

Courtesy, Tommy Yee

296

Courtesy, Tommy Yee

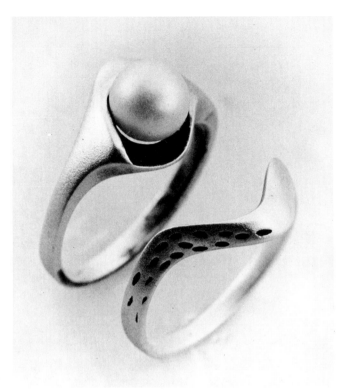

297

Courtesy, Griffith & Reiter

297–298—Arcadia, California, contemporary goldsmith Arnold Frew added a gold pearl to these cleverly designed interlocking wedding and engagement rings of gold, centrifugally cast from wax.

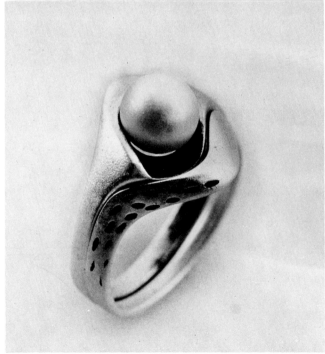

298

Courtesy, Griffith & Reiter

SLATE

In memory of
Miss Elizabeth Blackman
dau. of Mr. Samuel &
Mrs. Wattstill Blackman
who died 16 Jan. 1799
in the 38th year of
her age.

299—Early American tombstones are fine examples of direct carving in slate.

Slate is a common material associated in most people's minds with blackboards, roof tiles, hearths, and patio floors. One rarely sees it used as a sculptural medium today, which is unfortunate. Though slate has no veining like marble and most other stones, it has a beauty of its own adaptable to certain types of sculpture. Black is slate's common color, but there are low-key shades of green and red that, used sculpturally, are extremely beautiful.

Slate is a lamination of thin layers, which accounts for the fact that relatively thin sheets of it are much stronger than most people think. It varies in hardness, but the surface of the average piece is more easily worked than most stones. With a very few tools you can turn out a slate bas-relief of surprising quality.

Where do you get slate? Any used blackboard more than a quarter of an inch thick makes a perfect material for working. Its surface has been honed smooth. The large school-type blackboards are wonderful, even if they have been broken, but slate is obtainable at any building supply outlet. The most common form of slate at these places is flagstone (not to be confused with bluestone, which is much harder and too difficult to work). One way to ascertain the workability of a piece of slate is to scratch it with a nail and see how easily you dig in. Do not overlook the small fragments and splinters of slate always found lying around the stoneyard, usually yours for the asking, as these will often suggest your most interesting compositions.

For centuries, slate has been used widely as a medium for inscribed design. With simple tooling, great feeling of depth and variety of style are possible—anything from a plain incised line drawing to a true bas-relief.

This is a medium with a unique appeal to people who like to draw and who prefer a more deliberate and controlled approach to sculpture than clay or wax afford—for naturally a mistake in slate can be fatal.

The nice thing about this medium, though, is that the end result of your labor is a finished piece of work that needs no further processing, such as casting. For this reason, work in slate very clearly represents the much-discussed philosophy of the direct approach in art.

300

The early American slate tombstone is a magnificent example of the direct approach. Some carvers did not even bother to block out their letters or even to draw lines as guides—a super-direct approach. They simply took chisel and mallet in hand and started at one side, working across until they

got to the other side. If they ran out of room for all the letters in the last word, they ran them below with a little curlicue line joining them to the rest of the word.

Unlike clay or wax, which have no boundaries of form, slate confines the artist to the size and shape of the piece being worked on. While clay and wax are built up by modeling, in slate you start with a specific mass and take away material with careful calculation to reach a desired objective. This, incidentally, is the basic difference between modeling and sculpture that so few people seem to understand, for in modern times all modeling is clumped under the term sculpture.

This discussion of slate and the basic demonstrations of its use in the pictures have been restricted to very shallow bas-relief. Nevertheless, it constitutes a basic foundation, even a jumping-off-place, for doing deep bas-relief or sculpture-in-the-round in slate or other stones.

There are also a number of unexplored byways in the use of slate. Within some pieces, for instance, one may find areas of red with streaks of green; these can be used to augment design.

The black polished areas of a slate bas-relief often suggest further decorative elaboration. Line drawings inscribed in these surfaces may serve to enhance the composition and the final effect. In addition, a tasteful use of subtle coloration with paints or colored powders rubbed into the stone before waxing, or even gold leaf judiciously applied, may complement the carving.

301—Make your drawing on tracing paper.

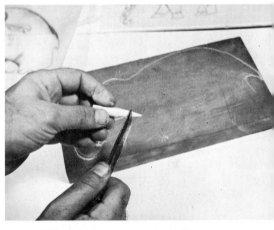

302—Transfer it to the slate.

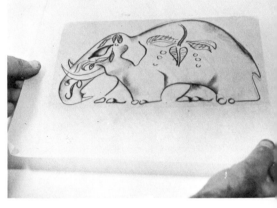

303—With sharpened chalk

304—outline the figure clearly.

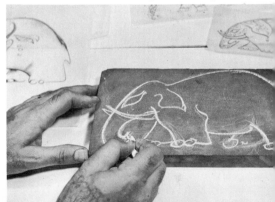

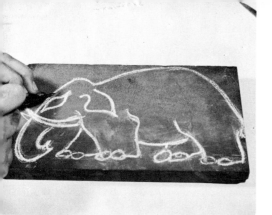

05—Define the outlines with a scriber.

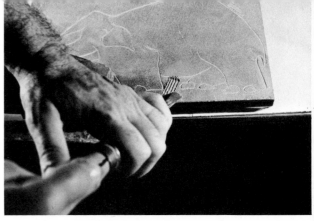

309—With toothed tool, texture background,

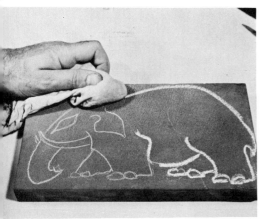

06—Erase chalk to see your scribe lines.

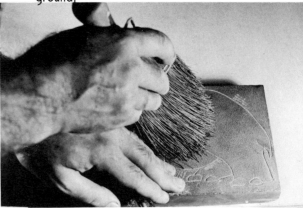

310—brushing off stone dust now and then.

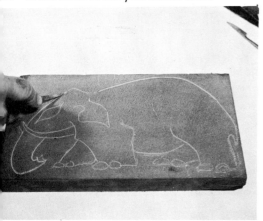

07—Force riffler file slowly along lines

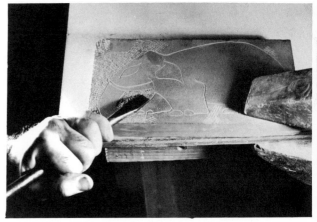

311—A clamp is handy to hold the slate.

08—with slight side-to-side rotation.

312—Sponge slate to clarify figure before

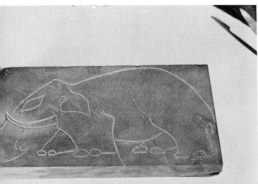

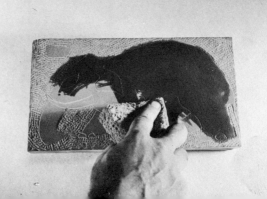

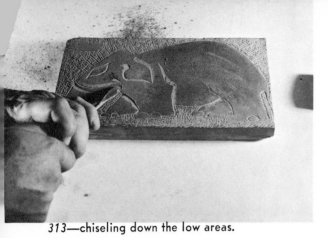

313—chiseling down the low areas.

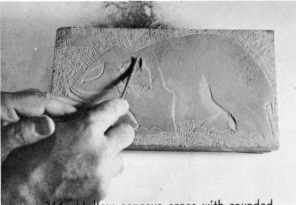

314—Hollow concave areas with rounded rasp.

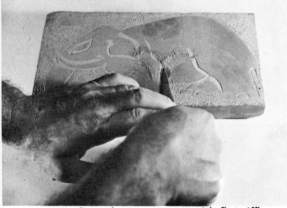

315—Smooth convex areas with flat riffler.

316—Finish all surfaces with emery cloth.

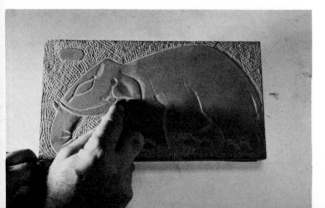

THE TOOLS FOR SLATE

1. SCRIBER—A leather scribing tool with a rubber handle is best. You need a lot of pressure to cut into the stone, and a rubber handle will save your hand. An awl or ice pick or even a sharpened nail stuck in a handle will do just as well, however.

2. ITALIAN RASP or RIFFLER —This is used to deepen the lines scratched with the scriber. The rasp or riffler is pushed forward slowly, following the scriber's scratch, and is controlled very carefully by a steady pressure. The forward movement of the tool is activated by a slight side-to-side rotation of the wrist, in very much the same way an engraver uses an engraving tool.

3. TOOTHED CHISEL—This can be used as a stone tool, and 2-, 3-, or 6-toothed chisels are available, the latter for texturing very broad surfaces. To save money, you can get as good results on slate by using a screw driver into which teeth have been filed.

Actually, any tool worked into the surface of a polished stone will turn it gray—the selection is up to you. A rasp, for instance, does just as well to whiten-in a background, but the toothed chisel is my preference for obtaining an interesting crosshatch background surface against which the waxed and polished figures seem to me to stand out with greater contrast.

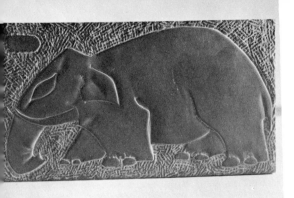

317—Elephant as it looks with carving done.

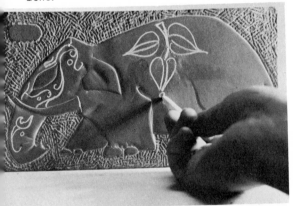

318—If desired, draw in surface decoration.

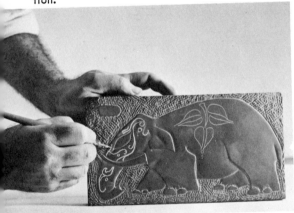

319—Again use the scriber.

320—Rub beeswax on surfaces to be polished.

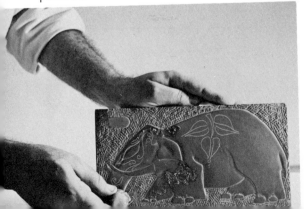

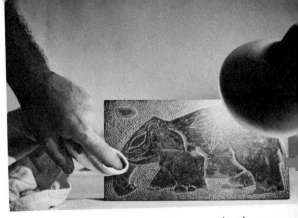

321—A heat lamp or the sun melts the wax

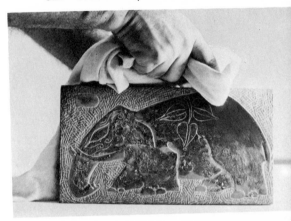

322—into the pores of the stone. Rub in.

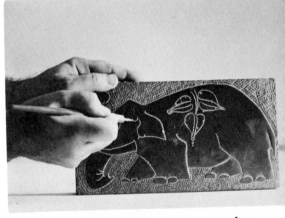

323—Use scriber to remove wax from lines.

324.

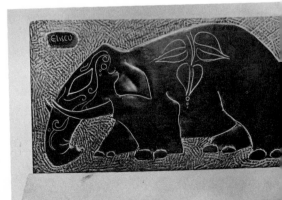

325—Sliver of slate suggests a reclining

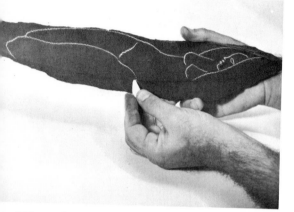

326—nude, simply sketched in with chalk.

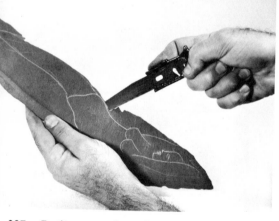

327—Outlines are shaped with a hack saw

328—and refined with a rasp.

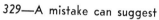

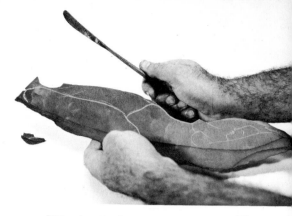

329—A mistake can suggest

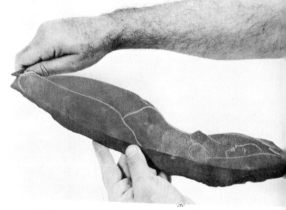

330—a redirection of design.

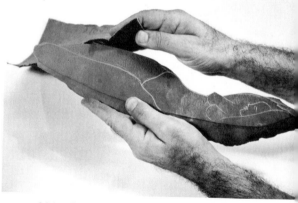

331—Outline is smoothed with emery cloth.

332—Enscribe the chalk lines before

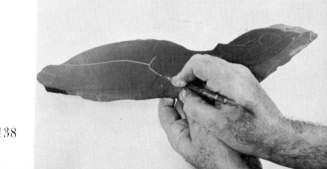

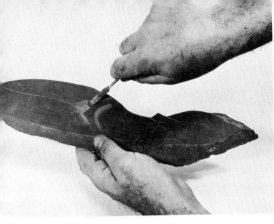

333—further sculpturing with rasp.

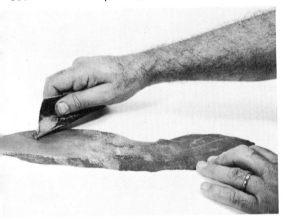

334—and smooth with fine emery paper.

335—Wax the figure before heating.

336—Polishing brings out the subtle form.

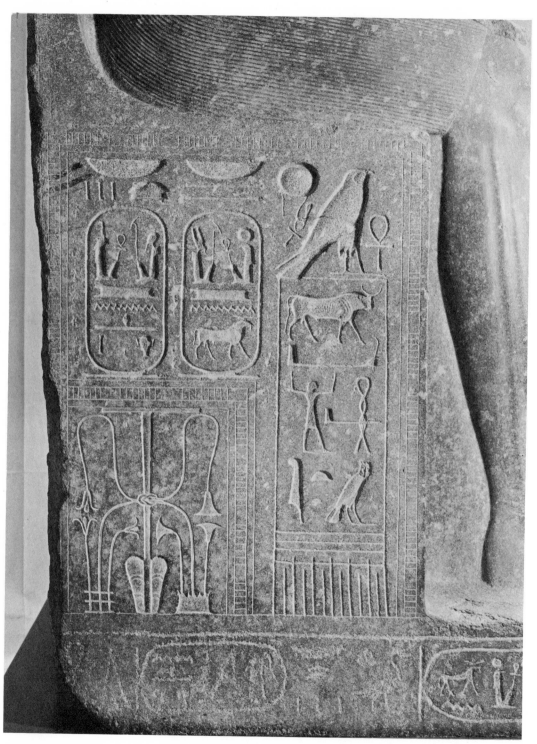

337

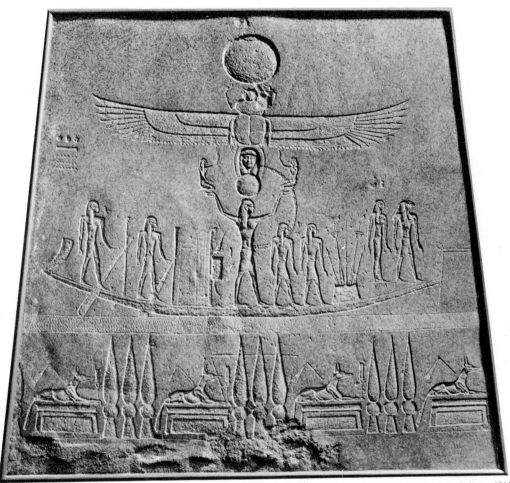

338

337–338—Wonderful early examples of low-relief carving were found in Egypt. Above: Top of lid of sarcophagus of the Prophet Mūt, 30th Dynasty, from Sakkara. Facing page: Detail of the relief on the side panel of a statue of Amenophis III is Egyptian 18th Dynasty.

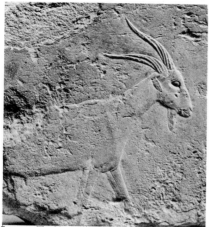

339–342—The four Egyptian limestone reliefs on these pages suggest how much expressive quality can be wrought in the face of any flat stone with a minimum of detail.

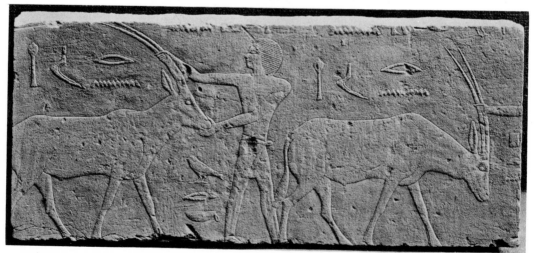

340

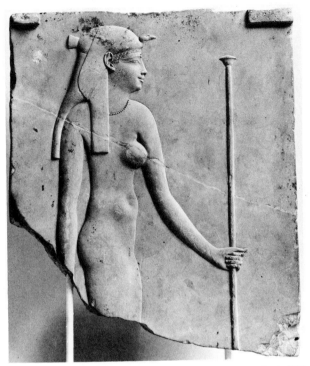

341

Courtesy, The Metropolitan Museum of Art, Rogers Fund, 1907

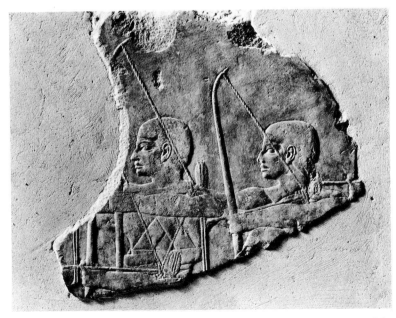

342

Courtesy, The Metropolitan Museum of Art,
Museum Excavations, 1920–1922

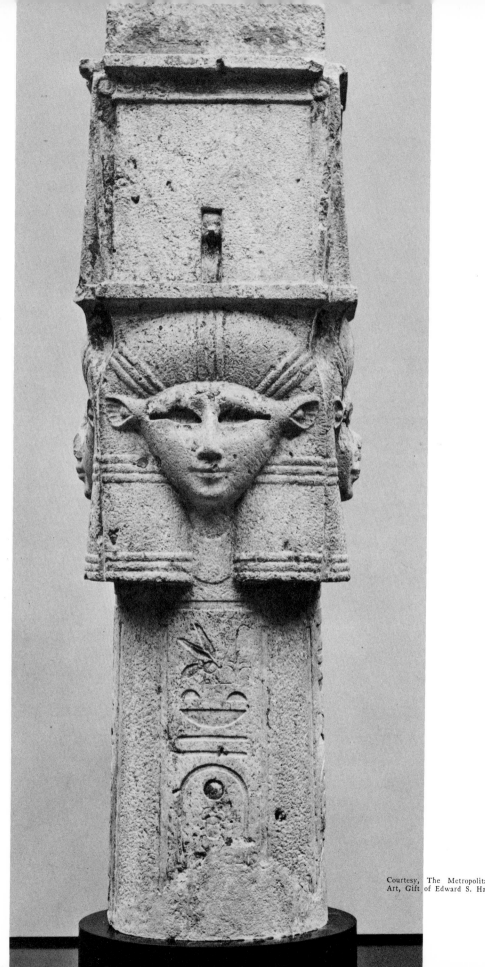

343

343–344—Facing page: 30th Dynasty Hathor Column is probably from the Delta of the Nile. Such deep-relief faces as these are an ideal transition stage for the sculptor who has become adept at shallow bas-relief and wants to graduate into sculpture-in-the-round. Right: A Chinese stele of about the sixth century A.D. shows a stylized dragon and plant motif in very shallow relief along its side. The figure seen in profile is practically in the round.

Courtesy, The Metropolitan Museum of Art, Rogers Fund, 1924

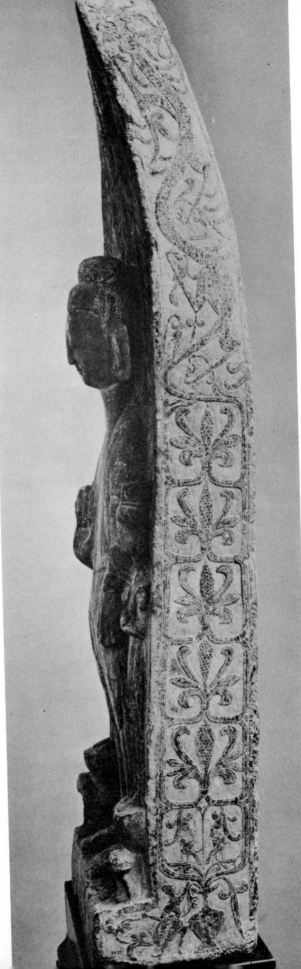

344

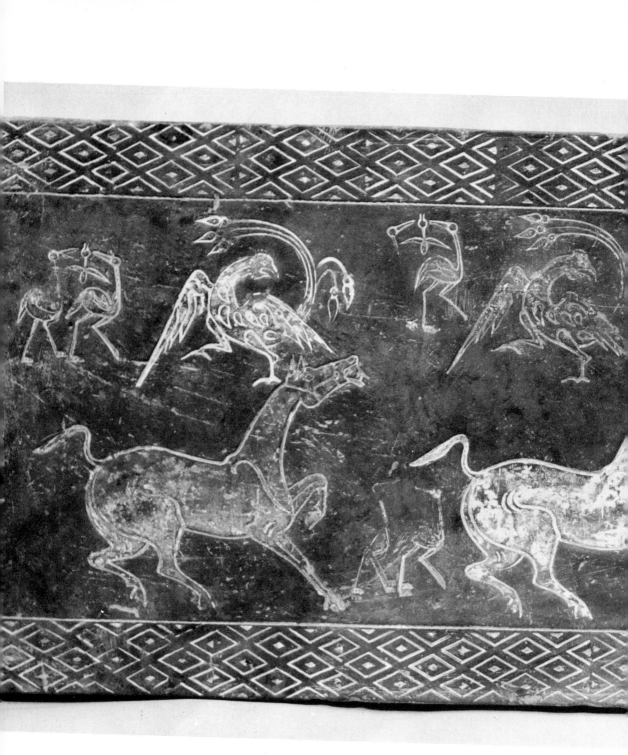

345—Although this Han Dynasty (206 B.C.–A.D. 220) Chinese sculpture is terra cotta, the sgraffitoed figures should have considerable design appeal for sculptors interested in decorative treatment of large flat areas. Casually juxtaposed, the same three repeated elements cover the entire surface of the piece.

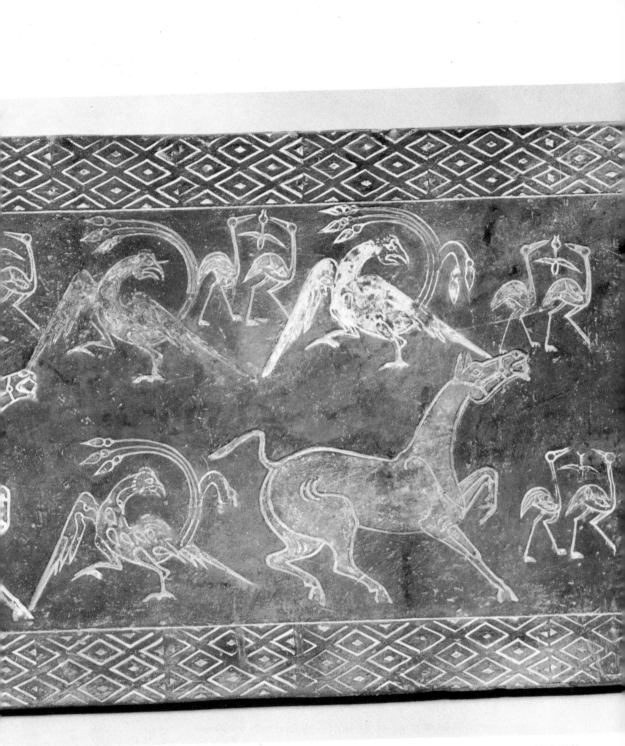

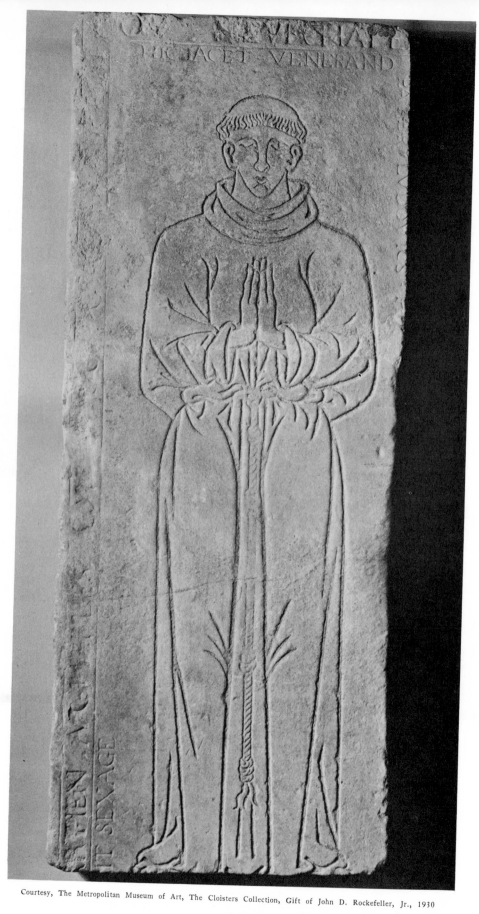

346

Courtesy, The Metropolitan Museum of Art, The Cloisters Collection, Gift of John D. Rockefeller, Jr., 1930

346–347—Facing page: A favorite of visitors to the Metropolitan Museum's Cloisters in New York is this life-size tomb slab of a monk, French, fourteenth century. The draping of the cloth is suggested with a minimum of lines in a striking symmetry. Below: Even more simply described than the monk is this 12″ slate slab of Daniel in the lion's den by the author.

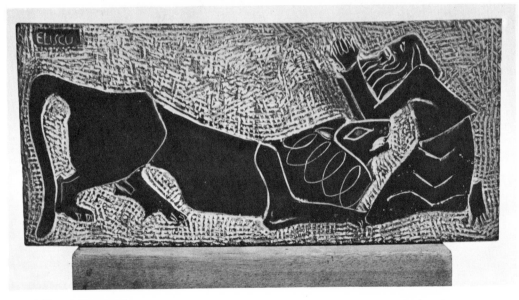

347

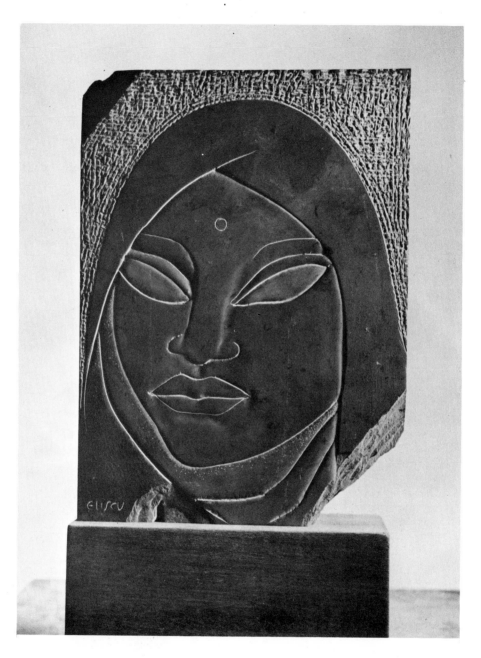

348

150

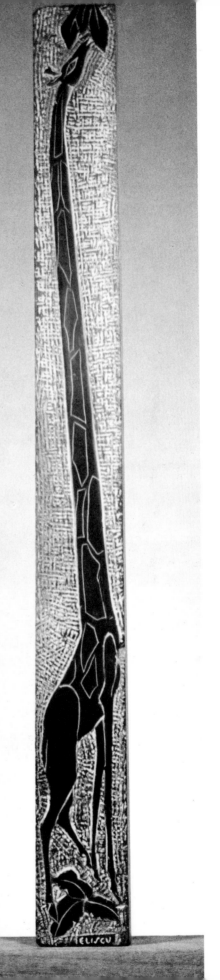

348–349—Two sculptures by the author are both done on fragments of salvaged school blackboards. The "Woman of India" on the facing page, 11", has been given mysteriously lighter eyes than the rest of the surface of the head simply by omitting the wax within these two ellipses. Enscribed rectilinear shapes suggest the typical markings of the giraffe on the slate relief at right, 15" high.

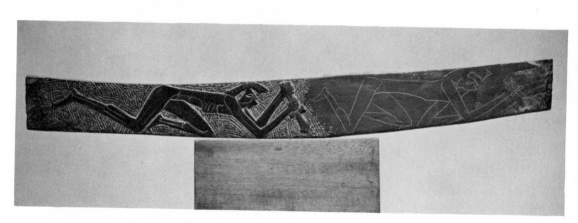

350—Partly completed slate, 14″, by the author, depicts crawling warriors.

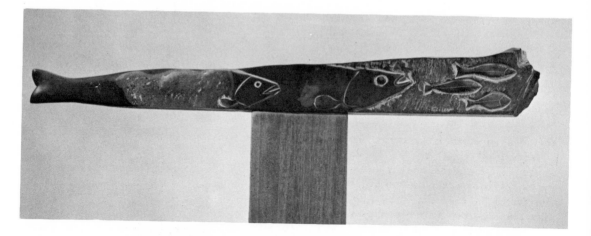

351—The unusual red markings in this 18″ fragment of green slate have been put to use in the design —one of the red spots has been made into a fish's eye.

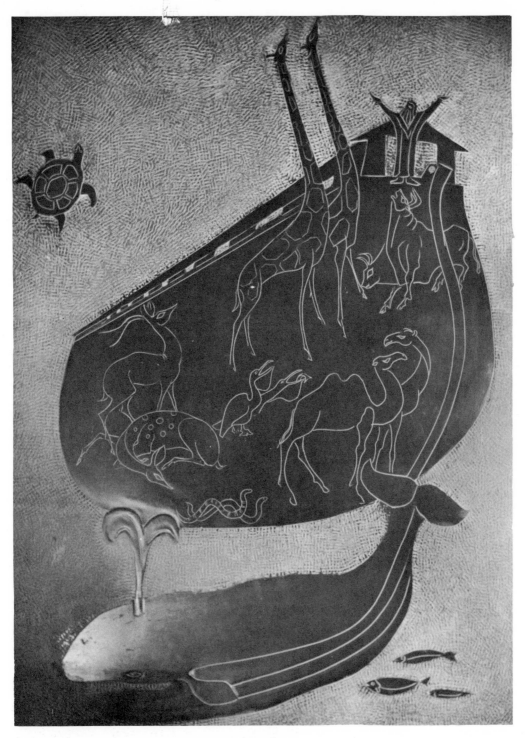

352—The author's "Noah's Ark" relies for added interest on enscribed animals covering a wide, otherwise unsculptured area of the design, 40″ x 30″.

353–355—Often the basic shape of a found fragment of slate will suggest a design. Such was the case in these three slates by the author. The monumental whale is actually a paper-thin sliver of slate only 9″ long; it is held by a small, gilded bronze fish cast from wax. On the facing page, the nude is a warm earth-red slate 20″ long; and the water buffalo another sliver 10″ long.

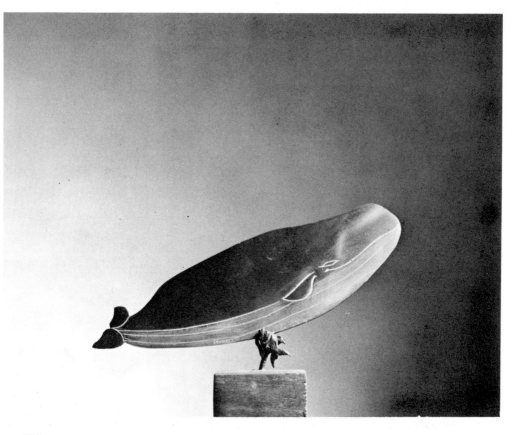

353

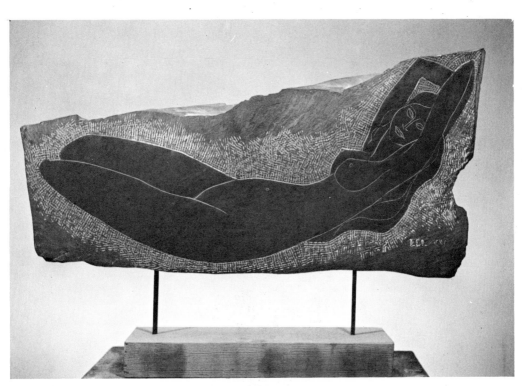

354

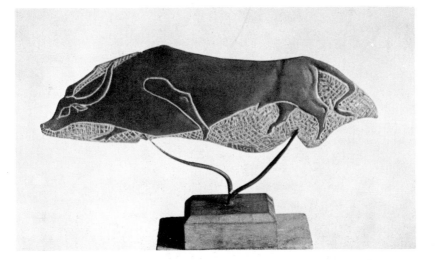

355

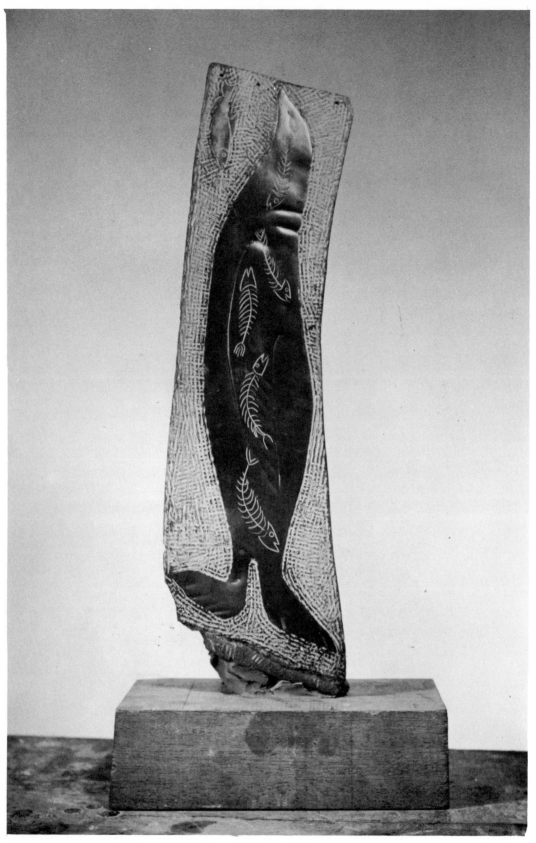

356

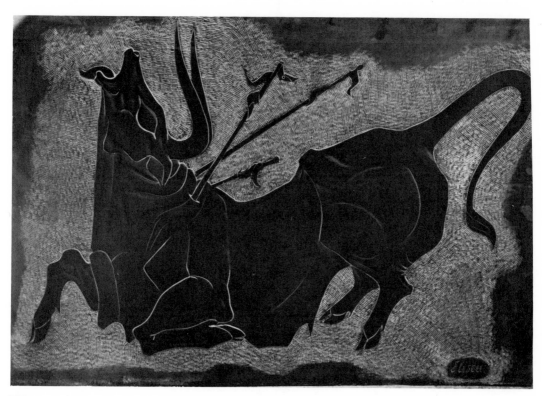

357

356–357—An entire blackboard was utilized for this relief of a bull in agony. On the facing page, the highly polished waxed surface of the seal gives him the appearance of having just splashed out of the water—the fish bones suggesting he has recently finished his lunch. The seal is 8″ high. Both slates are by the author.

358—Pecking hen by the author, 10″ long, has legs of bent and soldered brass wire.

PEBBLE
SCULPTURE

PEBBLES

Very like slate for sculpture, and much more available, are pebbles that suggest sculptural forms. Find them anywhere. You will, if you search, find a few that have immediate meaning for you in terms of design, a meaning you might accentuate easily and bring out of the stone for all to see with a little carving and polishing. Other pebbles will be so beautifully formed by nature that they are complete sculptural entities that man only would destroy in any attempt at improvement. If you test each one with a nail, you will discover that some are too hard to work—like granite or flint—others are soft enough to be worked in exactly the same way as slate. It is a perfect avenue to stone sculpture-in-the-round.

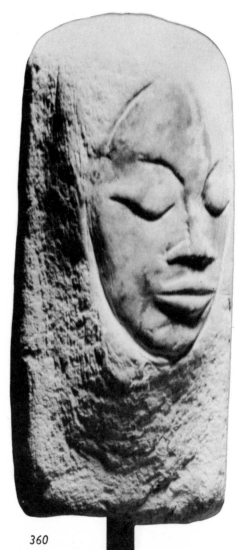

360

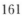

359

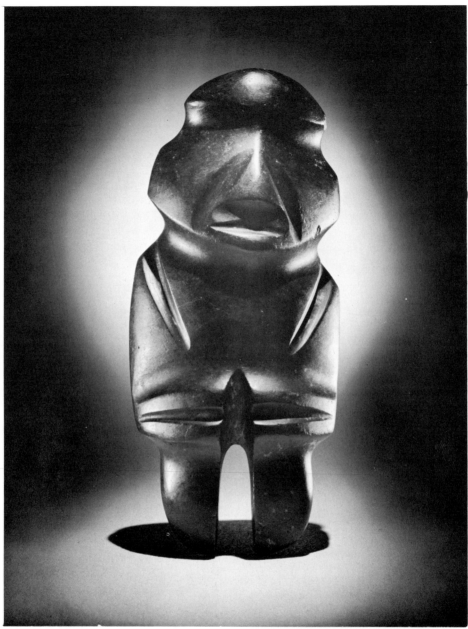

361

Courtesy, André Emmerich Gallery

361–362—A type of pebble sculpture in as sophisticated a form as any known to man are these pre-Columbian standing figures from the Mezcala culture of western Mexico, ca. 300 B.C.–A.D. 600, the one above 5″, the one on the facing page 10½″. Done in a civilization that did not yet know either the wheel or metal tools, these sculptures were probably made by rubbing harder stones against them, and by bows strung with leather thongs used with abrasive to cut the grooves. Made from celts, or hand-held axes, they appear to have been carved into figures when a man died, and then were buried with him—accounting for their fine state of preservation.

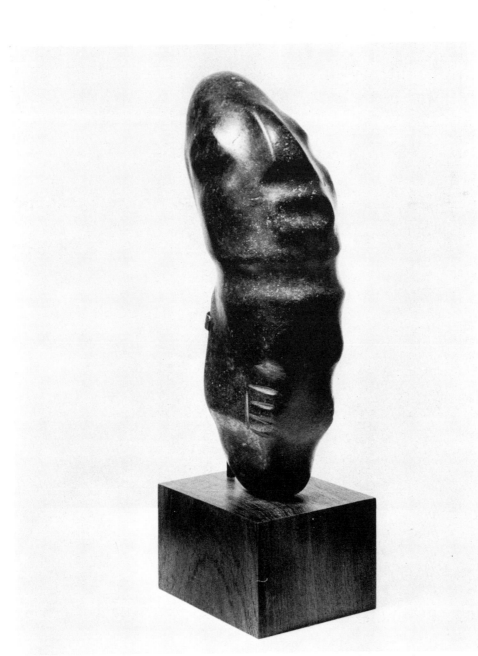

362

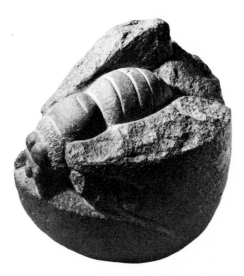

363

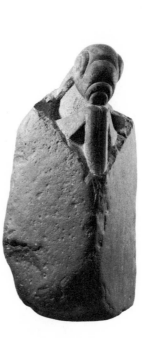

364

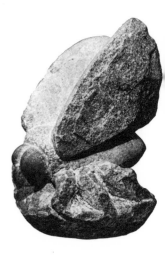

365

Jeremiah Russell, courtesy Sculpture Center

363–365—Contemporary sculptor Henry Di Spirito carves enormous insect forms from rocks—granite, sandstone, and others.

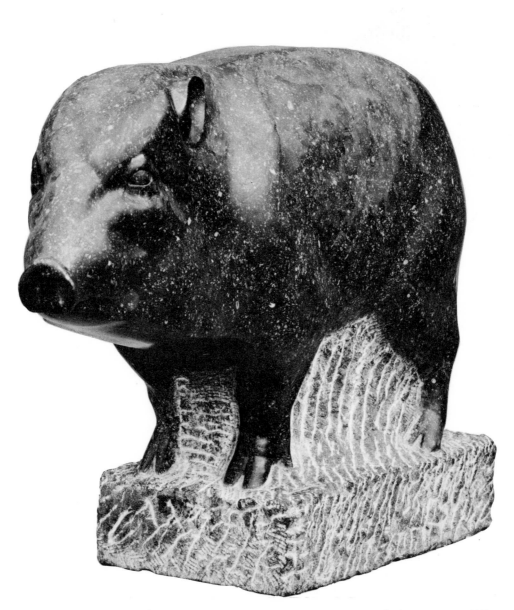

366—Peccary in black granite demonstrates where pebble sculpture can carry a sculptor; by modern French sculptor Georges Hilbert.

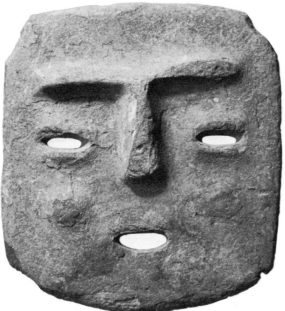

367—Eroded diorite mask, 7″ high, from ancient Mexican Mezcala culture of the state of Guerrero.

368—Red quartzite head generally considered the finest portrait in existence of the Egyptian Pharaoh Akhenaten, the "Heretic King," 1370–1353 B.C.

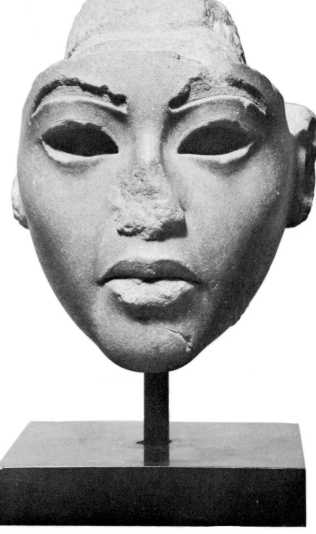

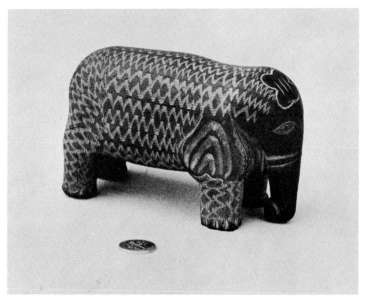

Courtesy, Smith Scherr & McDermott, Akron

369—This beguiling little pachyderm is a mid-twentieth-century folk sculpture from Korea. The dime in the foreground gives the scale.

GENESIS
OF A
STATUE

Generally speaking, people have a very limited idea of how sculpture gets to be. Even people who purchase the work of sculptors, their clients, often have only a hazy notion of the amount of work or the number of different phases involved in the production of a life-size statue. What is more, the neophyte cast adrift in the world of sculpture, one not having had the chance to work for or with a professional sculptor, may flounder badly trying to decide myriad questions, like whether to use wet clay or a greasy one in getting started, all the way through to his answer to the foundryman's question, "What kind of patina do you want on your bronze?"

The alternatives are legion at every step. Vital decisions have to be made early, and the sculptor must do the best he can to embark on the most practical course of action, since a tremendous investment in time and energy—to say nothing of materials— is always involved in the genesis of a statue.

Aside from the artistic ones, the mechanical and engineering problems involved in the birth of the Naiad (*shown on the dust cover of this book*) loomed enormous even before the best of the original sketches had been chosen. The marble background that would cover the walls of the lobby where the statue would go, for instance, had been ordered many months ahead of the actual construction of the building. The statue had to suit this marble. There were special waterproofing considerations, since far below its site runs a subway.

Actually, the Naiad was conceived when I, as one of four sculptors, was asked to compete for this commission. The competition was handled in the usual manner, with the four sculptors meeting with the architect and being given a deadline for a 3-inch-to-the-foot scale model to be submitted in just three months. It was predetermined that this was to be a fountain. We also were told the dimensions of the lobby and the size, shape, and location of the pool. Fac-

370—Wax sketches done quickly in search of an effective composition for the Naiad.

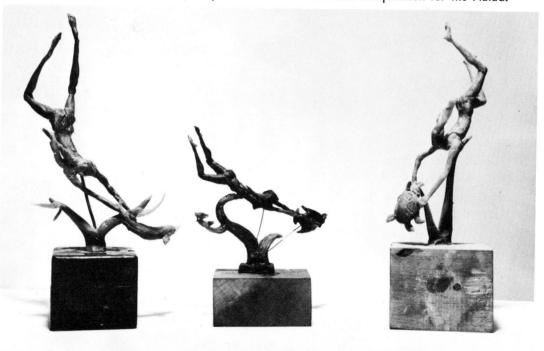

tors like the mosaic colors of the pool, overhead lighting, and the planting were determined later, dependent on the sculpture eventually designed for the space.

Some sculptors prefer drawings, some clay sketches; I work out my ideas in wax (Fig. 370). Since I wanted a young girl swimming through the water, I decided she should be towed by one of the denizens of the deep. Determining the right one was the problem. I finally chose a fish and modeled an imaginary one, purposely ugly and textured to contrast with the smooth beauty of the girl (Fig. 373). I built a small-scale cardboard model of the lobby wall and the pool in front of it, and tried each of a half-dozen different wax sketches against this model to see which seemed most appropriate. This also gave me an idea of scale and whatever feeling of monumentality was called for. These sketches were only a few inches high and were strictly for helping me determine which of several ideas along a similar theme I preferred.

Having made my choice, a scale model was made. It might have been one-third or one-half, but in this case was one-quarter life size. I worked this up in plastilene over a standard 18-inch figure armature.

The armature support of steel pipe rose outside the statue and entered it at the stomach, as this was to be the back view when the statue was installed in the lobby. Connected to this were heavy aluminum wires for the internal framework that extended through the length of the figure to the end of her four free-floating appendages. A single piece of lead wire, attached to the base, swung up and

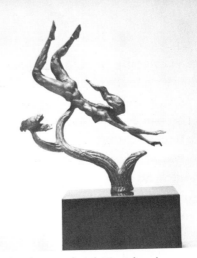

371—A wax sketch that has been cast in bronze by centrifugal casting.

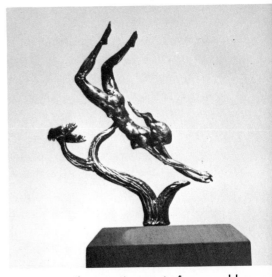

372—A silver casting made from a rubber mold of the bronze statuette.

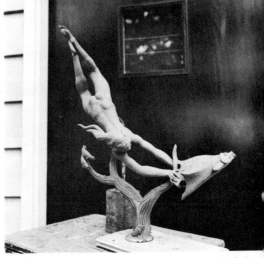

373—Original clay quarter-size model showing supporting frond the way it originally existed.

171

met the figure at a point that made the Naiad seem most comfortably balanced to the eye. The mind of the onlooker had no conscious or unconscious tendency, in other words, to want to "hold her up." This piece of lead wire was covered with clay to form a frond, and to it four little fish were attached from which sprays of water eventually would come shooting out.

As I worked at the clay model, some elements resolved themselves naturally. The hair, for instance, seemed to want to flow in a specific direction, and that's the way I let it go. This is merely one of the subjective characteristics of the sculptor's craft that every good sculptor takes advantage of—the tendency of the material to suggest its own solutions to problems as they arise. And new problems do arise in this larger dimension, of course, that do not appear in the much smaller wax, such as the play of planes and textures against one another. For example:

There was no texture at all in the supporting frond of the wax model, then the texture I put into it on the clay model proved too distracting. The solution was not reached until the final full-scale model was done, in which the texturing on the frond was faded out as it rose toward the figure. I cite this merely as a reason for carefully appraising the progress of the work at every stage.

As a matter of fact, the very night before I took this quarter-scale model to be cast, I received a snapshot taken of the nearly finished work and immediately realized that something about it was too fussy (Fig. 373). Perhaps I had been "too close" to my work to

have noticed this, and the photograph merely gave me a new perspective on it. Right on the snapshot itself, I tried blacking out with India ink one long branching stalk of the undersea frond and immediately perceived a great improvement. But this was a frond that joined the statue at the hands, and I was leery of removing it, for it had a certain function in supporting the weight of the statue. I had to keep constantly in mind that the weight of the full-size statue in bronze would be tremendous.

Thus, instead of simply lopping off the arm of the frond, I took the model next day to my caster, Vincent Russo, one of the finest in the trade, and told him I was worried about the ability of the plaster (and eventually the bronze) to balance itself on that single remaining stalk of the frond. He assured me that "if it holds in plaster it will hold in bronze."

I left the 18-inch-high, 21-inch-long clay model with Mr. Russo for the week he required to make this rather tricky cast. I picked it up—an identical quarter-scale model of the Naiad in plaster of Paris—a week before the competition's deadline. It was still quite wet, since it takes about a a week to become bone dry. To hurry the drying, I put it under infrared heat lamps, because I prefer to put the finishing touches on plaster when it is completely dry. Wet plaster is easier to carve, but this piece didn't need any major alterations. It was only the surface that needed touching up, and wet clay clogs the rasps and sandpaper anyway.

I cleaned off the joints where Mr. Russo had placed his shims that divided his cast, and polished away the

spots of blue mold plaster that Mr. Russo had overlooked in his haste to get the model back to me so I could make my deadline. Roughened surfaces were intensified and crisped up, smooth contours were softened until the forms flowed smoothly into each other (Fig. 374).

For this particular competition, it was required that the model be presented for judging in white plaster. Therefore patination (to make the plaster look like bronze) was not a concern. As this was an anonymous competition, an identifying symbol and my name were put in an envelope and sealed. A similar symbol was put on the statue—I used a fish.

Although I lived near enough to take the statue to be judged myself, if I had wanted it crated for shipment, I would have called in one of the companies that specialize in crat-

ing and transporting statuary (see Appendix).

The afternoon that I was informed that I had won the competition, the realization came over me that my real work was just beginning—I also confess to inevitable gnawing doubts as to whether the delicacy and charm of the original small model might be impossible for me to maintain under the sheer weight of bronze in the final version. But these are the pangs of metamorphosis in the genesis of any major sculpture commission.

Now began the long road to the final statue. Again there were many choices open to me. Some were easier than others; some matters of individual preference. Should I use wet clay or plastilene? The latter is a one-consistency medium. Clay, much less expensive in the quantities called for and much more sensitive (to me any-

374—The finished plaster model as submitted to the jury in competition.

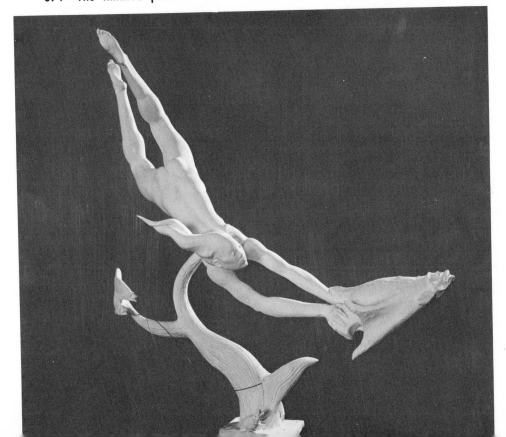

way) as a modeling medium, is much harder to keep damp and workable over the course of months. Should I enlarge from my quarter-size model right up to the full-size one, or do it in two steps, quarter to half and then to full? In enlarging from quarter to full size, you are working with the maximum safe enlarging scale, for a slight deviation magnified four times can result in an entirely wrong effect.

Some problems took care of themselves. The time allotted to me to complete the commission did not seem adequate for an extra stage, for example. Thus I determined to go on modeling during enlargement and make frequent checks with proportional dividers to keep myself on course. I decided to use plastilene because the complicated and attenuated pose would have made repeated wrapping and unwrapping of wet clay a tedious and hazardous chore.

The problem of the armature for the Naiad was a pure engineering one and a considerable one at that, for hundreds of pounds of plastilene were going to have to be balanced at a severe angle on a point that my proportional calipers told me was no more than 6 inches in diameter. An armature had to be developed that would not sway or give, in which I would have a feeling of complete security—for it is hard to imagine a worse fate for a sculptor than the collapse of a nearly finished life-size statue.

The armature was made of 3-inch heavy-walled pipe welded together with a heavy iron plate at its lower extremity. This in turn was bolted to a large wooden platform to negate any danger of the statue's tipping over. The inside framework was made of wood lath and wire mesh built up to within an inch of the desired form —the approximate dimensions were determined by use of the enlarging machine, a form of three-dimensional pantograph.

As I got ready for enlarging, I set the machine so that it would make an enlargement exactly four times the size of the plaster model of the Naiad. The model was also bolted down in an absolutely rigid permanent position so that its relationship to the armature would have no chance of changing until the statue was done (Fig. 375).

Now began the laborious task of building up clay around the armature. I brought in an assistant to help me, for 500 pounds had been emplaced by the time we were through. One of us worked the machine, establishing reference "points" while the other laid up clay (Fig. 376). Though I prefer to do my own, most sculptors these days send this phase of the work out to men who specialize in enlarging. These technicians are also able to make a "reduced" version of a large statue, which, of course, is the way many of the multiple copies of famous statuary currently on the market are made.

When the enlarging was completed, as I usually do, I remodeled the entire figure to establish a uniform balance and flow of forms (Fig. 377).

My finishing tools have serrated edges and surfaces which give an all-over hand-tooled aspect to the statue —the "touch of the hand" that is so important today to differentiate from mass-produced surfaces on which you never see the unselfconscious sort of

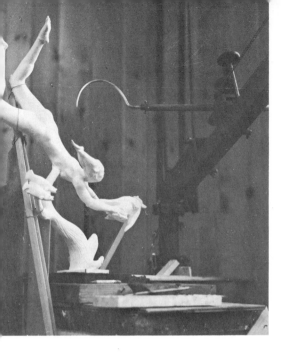

375—Model in place ready for the enlarging machine.

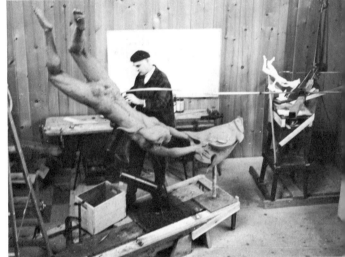

376—The enlarging machine in action.

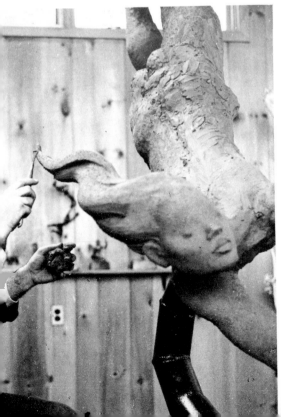

377—The head has been finished; the rounds on the coccyx and the shoulder are enlarging points made by the machine.

texturing that only the hand of man performs (Fig. 378).

This finished, full-scale plastilene stage is the point where I get the client to examine the statue carefully and make his suggestions for corrections—because once this stage is passed and the form is cast in plaster, no major changes can be made. It's a point of no return for sculptor and client alike (Fig. 379).

Fortunately, the Naiad was one of those jobs where everything seemed to go right, although in truth the client had been given a chance to become thoroughly familiar with the model, which he had approved without reservation. Enlarging therefore did not magnify any reservations he might have had. Although there is always a danger in enlargement from a small model, enlargement only increases the effect of a statuette that has true monumentality inherent in its form.

The Naiad didn't wait very long for casting. The client's O.K. came quickly. If for some reason I had had to wait a long time for the arrival of the client at my studio, if he had lived a great distance away, I would have kept the statue carefully covered to keep dust off it, for expensive plastilene can be used over and over for many years, as long as dust is not allowed to rob it of its plasticity. Supported, a plastilene statue can stand for months, although inevitably it will develop cracks sooner or later, since it, like everything else, is susceptible to climatic changes which make it expand and shrink imperceptibly.

Just before casting the statue into plaster of Paris, my assistant, Paul Rudin, and I had a man from the

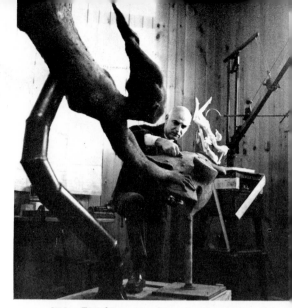

378—Finishing touches on the major fish, showing the armature pipe supporting the weight of the Naiad during modeling.

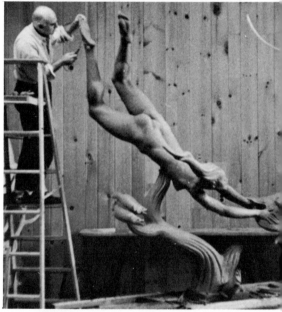

379—The pointed and modeled figure receives finishing touches on hard-to-reach places.

380—The plaster of Paris mold covers the clay form in sections divided by rows of brass shims stuck in the clay.

foundry come for a conference and help us decide which were the best places to establish the Roman joints where the various parts of both the full-scale plaster model and the final bronze statue would join together into a single form. A consultation like this not only saves the foundry headaches, but ensures the sculptor a better bronze.

The next step was the casting of the statue into plaster in 10 inter-locking parts. This job was handled by Rudin, whom I left alone in my studio with the Naiad for nearly a month, the 10 separate parts of the statue and the equal number of Roman joints making this a particularly challenging operation.

Briefly, this is how my assistant cast the full-scale Naiad into plaster. First, he divided the plastilene with little walls of shims over the statue's entire surface and covered it with a plaster of Paris jacket—which is the mold (Fig. 380). It came off in 20 or 30 pieces, looking like the giant jigsaw puzzle it really was (Figs. 381 and 382). The inner surfaces of this mold were cleaned and the parts of the mold for each separate dependency—like the arms, legs, and head—were put back together and cast separately, with a Roman joint at the terminus where each would insert into the torso (Figs. 384–387).

While still wet, all the seams, nicks, and the many, many little holes in the new, full-scale plaster model were reworked with steel tools to crisp up the surface and again bring back as much of the original life as possible (Fig. 388).

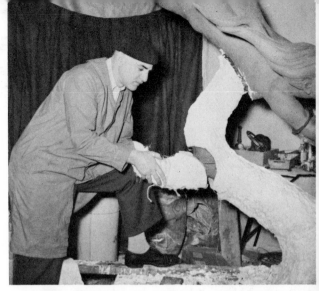

381—Removing a branch of the mold from the main support.

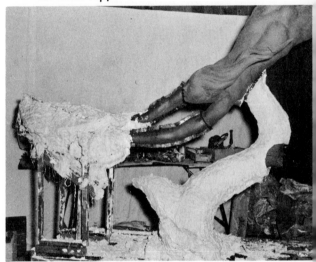

382—Another view of the process of making the mold.

383—The Naiad nearly embedded in the plaster mold, with wood braces supporting its great weight.

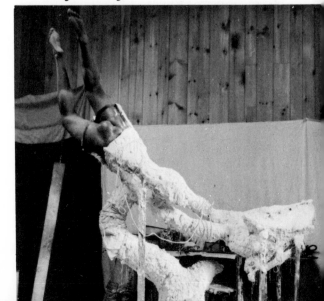

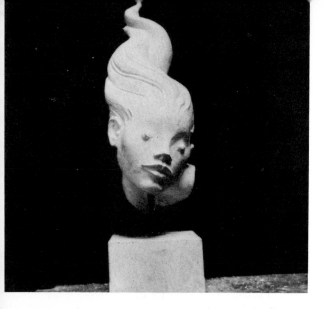

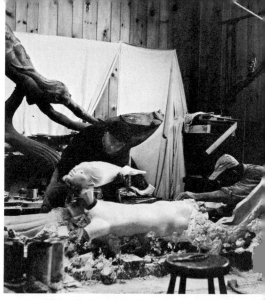

387—A stage in the course of making t[] full-scale model.

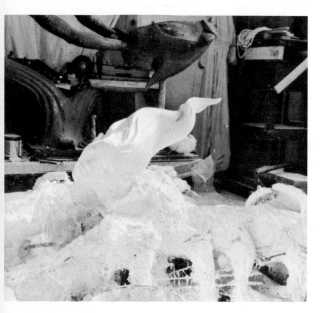

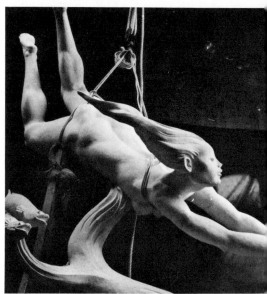

384–386—Head of the Naiad, showing how it fits into the body, with steel reinforced Roman joints.

388—The finished plaster cast; until [] dries, the water in the plaster makes it to[] heavy to be safely self-supporting.

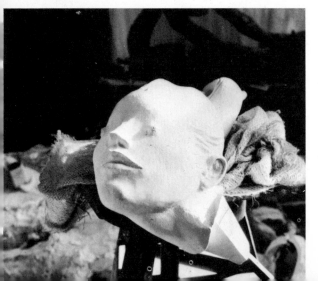

Now we were ready for the trip to the foundry 50 miles from my studio. The Naiad's first trip out into the world was piecemeal—two station wagon loads of her, with the head on the front seat and a leg sticking out the window.

At the Modern Art Foundry, in New York, my problems with her ended and founder John Spring's began. In this particular cast, with the figure to be supported by the rela-

tively light frond, a steel rod for reinforcement, running all the way from the base up the frond and well into the body, had to be planned as an integral element of the casting.

Since this was a fountain, with the figure to be splashed continuously with water, the jets and the piping also had to be planned to work into the casting. The foundry was given a plan showing where the four sprays would go. I could now relax until my return to examine the Naiad in wax.

This is an important stage, for a shell-like wax reproduction was made of each of the parts of the statue, the thickness of the wax determining the eventual thickness of the bronze. I had to check against the rare possibility that there had been any deviation from the original. The wax stage also affords an opportunity to add a texture, or to crisp up modeling, or perhaps to add the sculptor's signature—in fact, one sculptor I know adds his thumb print in the wax.

With the wax model approved, I left the foundry, knowing that the next time I would see the Naiad she would be in bronze.

This statue, cast in 10 separate pieces, was an especially clean cast, for when I returned a couple of weeks later, there was remarkably little porosity (tiny holes in the bronze which are very difficult to eliminate completely in any casting). I was thrilled at the sight.

Now the parts were all fitted together at the Roman joints. These long-planned-for joints assured that all the elements of the statue were in exactly the same relation to one another as in the model. Each joint was welded and the weld chased over,

completely obliterating it, so that the Naiad became a one dimensionally stable piece of metal. Finally, the entire statue was chased by a foundryman using the original plaster model for reference. Here, as at most foundries, the man who did the chasing was a remarkable craftsman, able to make a completely faithful duplication of my original surface texture.

Henceforth referred to by us as "the bronze," the Naiad was ready for the patination. I had been sent a 2-foot by 2-foot slab of the actual marble that had been selected for the wall behind the Naiad in the lobby in order to give me an adequate idea of what the statue's background would look like. Since she was a water subject, a greenish, waterlike patina suggested itself—although the shades and effects possible in patinas are infinite. I decided on one called "transparent green," which meant most of the bronze was to show through, with small patches of subtle green here and there to represent weathering.

I felt this reference to the past was especially appropriate in a modern building to warm up the typically geometric and relatively cold impersonal lines of the interior.

The patina was applied with acids and a torch in about 2 hours while I watched.

My next worry was the installation. The template on which the statue would stand had already been installed in the bottom of the pool in the lobby at 100 Church Street in Manhattan, and was waiting to receive the figure.

She arrived by truck uncrated one hot summer's morning; the workers at the site had been alerted to give a

179

hand and carry her in quickly. Nevertheless, nothing attracts a crowd in New York like a naked lady being carried through the streets—and this was no exception. It was as if a fire had started, with people running from either end of the block. The workmen's embarrassment and their asides to the audience, in trying to determine just which areas of the statue's anatomy to grasp in lifting her, afforded considerable amusement to the crowd.

Once the statue was in place and bolted into the template, plumbers were called in to attach pipes for the sprays and adjust the pressure, so that the Naiad would be bathed continuously—giving a startling illusion of a figure swimming through the water. The architect, Richard Roth, and I spent a wet half hour adjusting the angle of the sprays for the best effect.

Work was still under way in the lobby and the building still closed to the public when I left. On my next trip to New York, I visited the Naiad (Fig. 389). The effect, with the lights, water, and planting, exceeded my fondest expectations, for the ultimate compliment to any sculpture was in evidence in this busy lobby: people bustling in or out invariably stopped in front of the pool over which the Naiad appears to float.

Some were discussing the relative merits of the statuary, but I overheard one harried young mother, with her children whom she'd brought in off the sweltering street to see the Naiad, exclaim to another bystander, "Oh, how cool it makes you feel!"

POSTSCRIPT

We have given you here an intimate look at three sculptural media, two of which are seldom used today.

Do not be afraid to begin. Do not be intimidated by any fear—or awe—of the word "Art." Remember that no artist ever started a piece of work with anything more than his two hands and an idea. You will discover that even a tentative excursion into the area of three-dimensional expression is a completely absorbing experience and one that may give your life a whole new direction.

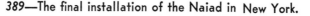

389—The final installation of the Naiad in New York.

APPENDIX

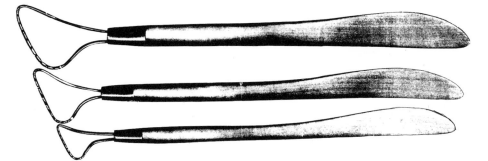

Clay Modeling Tools

Clay Modeling Armatures

Rasps for Slate

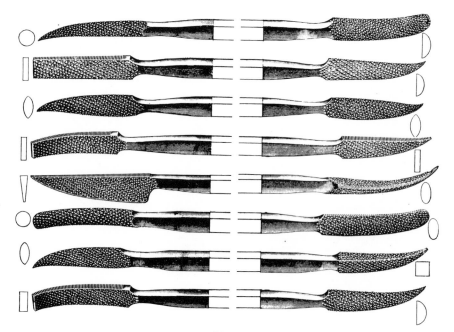

SCULPTORS' SUPPLIERS

BRASS FOR SHIMS

Whitehead Metal Products Co., Inc.
303 West 10th Street
New York 14, N. Y.
WAtkins 4-1500

BRONZE FOUNDRIES

Bedi-Rassy Art Foundry
227-31 India Street
Greenpoint, Brooklyn 22, N. Y.
EVergreen 3-4191
Modern Art Foundry, Inc.
18-70 Forty-first Street
Long Island City 5, N. Y.
RAvenswood 8-2030
Roman Bronze Works, Inc.
96-18 Forty-third Avenue
Corona, N. Y.
HAvemeyer 9-4402-03

ENLARGING—REDUCING—POINTING

Calabro, John
64 Highland Avenue
Demarest, N. J.
FOrt Lee 8-7826
Leofanti, Gene (Scrape Method)
20 Bank Place
Dongan Hills 4, S. I., N. Y.
ELgin 1-2990
Rochette & Parzini Corp.
218 East 25th Street
New York 10, N. Y.
(Also Sculptural Enlarging—Models
—Plaster Casting)
LExington 2-0660-1
John Rochovansky
North Avenue
Westport, Conn.
CA 7-2210
Sculpture House
38 East 30th Street
New York, N. Y.
ORange 9-7474
Tagliabue, Angelo (Architectural)
(Roman Bronze Worker)
1805 Summit Avenue
Union City, N. J.
UNion 5-4786

KILNS FOR FIRING

Drakenfeld & Co., Inc.
45-47 Park Place
New York 7, N. Y.
BArclay 7-6810

MODELING TOOLS

Ettl Studios
Ettl Art Center
Glenville, Conn.
Flax's
255 Kearney Street
San Francisco 8, Calif.
YUkon 2-4824
Martini, M. (Also Ceramic Steel Tools
—Catalog on request)
Milton, N. Y.
Robert Schneider—Stony Brook Studio
80 Stonybrook Road
Fairfield, Conn.
CL 9-0997
Sculpture Associates
101 St. Mark's Place
New York 9, N. Y.
ALgonquin 4-7800
Sculpture House
38 East 30th Street
New York, N. Y.
ORange 9-7474

MODELING WAX
(10-pound lots)

Eastern Mohair & Trading Co., Inc.
99 Hudson Street
New York, N. Y.
WAlker 5-9567
Sculpture Associates
Dept. A
101 St. Mark's Place
New York 9, N. Y.
ALgonquin 4-7800
Sculpture House
38 East 30th Street
New York 16, N. Y.
ORange 9-7474

PACKERS—MOVERS—SHIPPERS
ART OBJECTS AND MATERIALS
(*Long Distance)

Berkeley Express & Moving Co.
526 West Broadway
New York 12, N. Y.
GRamercy 3-5310

*Budworth, W. S. & Son, Inc.
424 West 52nd Street
New York 19, N. Y.
COlumbus 5-2194

Florio, Nick, Express
363 East 71st Street
New York 21, N. Y.
BUtterfield 8-9190

Gerosa Haulage & Warehouse Corp.
(Heavy)
777 East 138th Street
Bronx 54, N. Y.
MOtt Haven 9-5700

Hahn Bros. Fireproof Warehouses, Inc.
(Also Storage)
231-35 East 55th Street
New York 22, N. Y.
PLaza 3-3662
107-20 West 107th Street
New York 25, N. Y.
ACademy 2-3670

Hayes Storage, Inc.
305 East 61st Street
New York 21, N. Y.
TEmpleton 8-5510

*Liberty Return Loads Association, Inc.
385 Bleecker Street
New York 14, N. Y.
CHelsea 3-3939

Manhattan Storage & Warehouse Co.
52nd Street and Seventh Avenue
New York 19, N. Y.
CIrcle 7-1700
80th Street and Third Avenue
New York 21, N. Y.
REgent 4-6700

Seneca Moving & Storage
302 West 56th Street
New York 19, N. Y.
CIrcle 6-5179

*Thorn's Transfer, Inc. (Between
N. Y. C. & Westchester Co.)
29 Milburn Street
Bronxville 8, N. Y.
DEerfield 7-1260-1680
N. Y. Phone: FAirbanks 4-6636

PEDESTALS AND BASES
MARBLE

Cullo, James & Son Marble Co., Inc.
2044 Westchester Avenue
Bronx 61, N. Y.
TAlmadge 3-5800

Grand Marble Works, Inc.
932 Grand Street
Brooklyn 6, N. Y.
STag 2-2300

Miller-Druck Co., Inc.
756 East 134th Street
Bronx 54, N. Y.
MElrose 5-5810

Musto, Joseph Sons-Keenan Co.
525 N. Point Street
San Francisco, Calif.

Ratti, Guido
84-50—130th Street
Richmond Hill, N. Y.

Schmieg & Kotzian
521 East 72nd Street
New York 21, N. Y.
BUtterfield 8-8165

Schvetz & Hadeler
241-243 East 127th Street
New York 35, N. Y.
SAcramento 2-2390

Standard Marble Works, Inc.
242-246 Java Street
Brooklyn 22, N. Y.
EVergreen 9-4412

Trani, G. Marble & Tile Works
220 East 24th Street
New York 10, N. Y.
LExington 2-0258

Vermont Marble Co. (Imported and
Domestic) (Also Shop Carving)
101 Park Avenue
New York 17, N. Y.
MUrray Hill 3-8324-5-6

WOOD

Haas Wood & Ivory Works
64 Clementina Street
San Francisco, Calif.

Hasbrouck, C. A. & Son, Inc.
861 Third Avenue
New York 22, N. Y.
MUrray Hill 8-6965

Reliable Woodworkers Co.
325 East 29th Street
New York 16, N. Y.
LExington 2-1966

Sculpture Associates
101 St. Mark's Place
New York 9, N. Y.
ALgonquin 4-7800

PHOTOGRAPHERS (*Enlargements and Photo Murals)

Abbate Studios
10 East 40th Street
New York 16, N. Y.
LExington 2-6720

Baker, Oliver
25 Washington Square
New York 12, N. Y.
ORegon 4-5080

*Bruning, Charles & Co., Inc.
100 Read Street
New York 23, N. Y.
BArclay 7-8300

*Juley, Peter A. & Son
225 West 57th Street
New York 19, N. Y.
COlumbus 5-4494

Russell, Jeremiah W.
51 West 19th Street
New York 11, N. Y.
ALgonquin 5-8342

PLASTELINE

Behlen, H. & Bro., Inc.
10 Christopher Street
New York 14, N. Y.
CHelsea 2-3748

Ettl Studios
Ettl Art Center
Glenville, Conn.

Sculpture House
38 East 30th Street
New York, N. Y.
ORange 9-7474

Stewart Clay Co., Inc.
133 Mulberry Street
New York 13, N. Y.
CAnal 6-7452

PLASTER

Knickerbocker Plaster Co., Inc.
522 West 38th Street
New York 18, N. Y.
LOngacre 3-5520

PLASTER CASTERS

Alexander's Sculptural Supply
117 East 39th Street
New York 16, N. Y.
LExington 2-2850

Caproni Galleries of Amadeo, Inc.
1914 Washington Street
Boston, Mass.
HIG. 3762

Cassettari, Ned
8 Cummings Road
Lexington, Mass.
VOlunteer 2-3044

Contemporary Arts (Quantity Reproduction)
31 Stanhope Street
Boston 16, Mass.
KE 6-9525

Contini, Attilio J. & Sons, Inc.
340 West 12th Street
New York 14, N. Y.
WAtkins 9-2564

Haug, Herman
R. D. #1, Marlboro, N. Y.

Motroni, Hugo (Plastics and Rubber Reproductions of Anatomy)
1062-66 College Avenue
Bronx 52, N. Y.
CYpress 3-2580

Nardini, A. P.
1914 Washington Street
Boston, Mass.

Russo, Vincent
407 West 18th Street
New York 11, N. Y.
CHelsea 2-2242

Sculpture House
38 East 30th Street
New York, N. Y.
ORange 9-7474

Tauriello, Danile
8751 24th Avenue
Brooklyn, N. Y.
ESplanade 2-2193

PLASTER TOOLS (*Also Rasps and Riffles)

*Ettl Studios
 Ettl Art Center
 Glenville, Conn.
Martini, M. (Also Ceramic Steel Tools)
 Milton, N. Y.
Sculpture Associates
 101 St. Mark's Place
 New York 9, N. Y.
 ALgonquin 4-7800
Sculpture House
 38 East 30th Street
 New York, N. Y.
 ORange 9-7474

SLATE

Acme Slate Blackboard Co.
 254 Third Avenue
 Brooklyn, N. Y.
 MAin 4-7562
Mills Cut Stone Co.
 Virginia Road
 White Plains, N. Y.
 WHite Plains 6-3443

STONE CARVING TOOLS FOR SLATE

Alexander's Sculptural Supply
 117 East 39th Street
 New York 16, N. Y.
 LExington 2-2850
Sculpture Associates
 101 St. Mark's Place
 New York 9, N. Y.
 ALgonquin 4-7800
Sculpture House
 38 East 30th Street
 New York, N. Y.
 ORange 9-7474

TERRA COTTA CERAMICS
(Ceramic Supplies—Clay—Glaze—Tools)

*Ettl Studios
 Ettl Art Center
 Glenville, Conn.
Greenwich House Pottery (School)
 16 Jones Street
 New York 14, N. Y.
 CHelsea 2-4106
Stewart Clay Co., Inc.
 133 Mulberry Street
 New York 13, N. Y.
 CAnal 6-7452

TERRA COTTA WET CLAY

American Art Clay Co.
 4717 West 16th Street
 Indianapolis 8, Ind.
Drakenfeld & Co., Inc.
 45-47 Park Place
 New York 7, N. Y.
 BArclay 7-6809
*Ettl Studios
 Ettl Art Center
 Glenville, Conn.
Stewart Clay Co., Inc.
 133 Mulberry Street
 New York 13, N. Y.
 CAnal 6-7452

TOOL SHARPENING

Rainone, V.
 348 East 110th Street
 New York 29, N. Y.
 LEhigh 4-4578

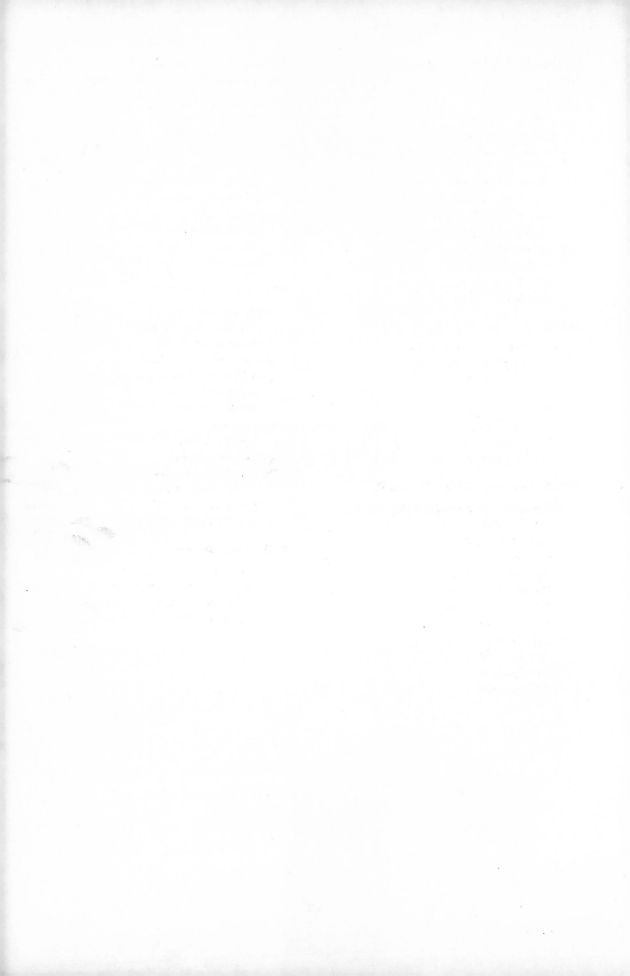

INDEX

INDEX

(Numerals in *italics* refer to illustrations)

Acetylene torch, 66
Achilles, *49*
Acid, use of, in patination, 122, 179
Acrobats, by Earl Krentzin, *127*
Action, how to indicate, 81
African plaques, *104, 105*
Aging, 122
Air bubbles in clay, 15
Akhenaten, head of, *166*
Amenophis III, statue of, *140*
America, wax portrait medallions in, 64
Appendages, changing direction of, 77
Appendix, 181–187
Armature, 22, 38
 for full-scale "Naiad," *174*
 how used in scale model of "Naiad," 171–172
 illustration of, *182*
 materials used for, 38
 skeleton as human, 44
 when to avoid use of, 22, 38
 when to use, 22, 38
Arrezzo, terra-cotta relief from, *48*
Asbestos, used in investment, 121
Awl, as used with slate, 136

Balsa wood, use of, in wax modeling, 65
Balzac, head of, *37*
Baroque, influence of, on Degas waxes, 83
Base, for sculpture, 122
Bas-relief, 133, 134
 casting of, 121
Bat, of plaster of Paris, 40
Bear, modeling of, *21–22*
Beeswax, 64
Benin, sculpture from, *104, 105*
Blowtorch, use of, in patination, 122, 179
Bluestone, 133
Board, as modeling tool, 38
Borglum, S. H., sculpture of, *106*
Bouchard, Henri, sculpture of, *98*
Bracing, iron pipe, 119
Brickworks, for clay firing, 17
Bronze founder, importance of, 121

Bronze foundry, 121–123
 procedures at, 121–122
Brynner, Irena, jewelry by, *129*
Bull in agony, slate by author, *157*
"Bulls Fighting," *106*
"Burning Bush," *28–31*
Burnout, 122

Care of wet modeling clay, 39–40
Cast jewelry, 123
Casting, 117–130
 centrifugal, *125–127*
 centrifugal machinery for, 65
 French sand process of, 121
 how to prepare model for, 119
 lost-wax process of, 121
 of "Naiad" into plaster of Paris, 177
 oven used in, 122
 procedure of, 119–123
 role played by dental technicians in, 65
 techniques of, 119
 use of plaster of Paris in, 119
Casting foundry, 119
Casts, not made by sculptor, 119
Cellini, Benvenuto, 121
Centrifugal casting, *125–127*
Centrifuge, in casting, 65
Chasing, 122
 of "Naiad," 179
China, pottery and sculpture of, 17, *146–147*
Chinese stele, *145*
Chisel, toothed, 136
Cire-perdue process, 121
Classic period, clay sculpture in, 17
Clay, 13–62
 advantages of, 40
 air bubbles in, 15
 care of wet, 39–40
 defined, 14
 drying of, 39–40
 firing of, 17
 forms used, 14
 how to keep workable, 39–40
 importance of compression, 15
 preparation of, 14
 "short," 39

Clay—(*Continued*)
 shrinkage of, 14
 "silky," 39
 slabs, 17
 as transient medium, 41
 as used in "Naiad," 174
 vs. plastilene, 38, 173–174
 wedging of, 15
 where obtained, 14
Clay modeling tools, *182*
Clay sculpture, firing of, 17
 history of, 17
Colima, example of style, *53*
Color, use of, with slate, 134
"Come Hither," *106*
"Coming Out," *23*
Composition, 81
Compression, of clay, 15
"Conversion of Saul," *96*
Cook, Robert, sculpture of, *100, 101*
Copies, how made, 174
Copper wire, use of in, wax modeling, 65
Cornell Medical School, war memorial of, *60*
Cracking, during firing, 40
Crawling warriors, slate by author, *152*

Dancing girl, sculpture by the author, *109*
 sculpture by Troubetzkoy, *108*
Daniel in the lion's den, sculpture by author, *149*
Death masks, Roman, 64
Degas, Edgar, 41, 64, 83
 portfolio of waxes by, *82–93*
Dental technicians, role played in new casting developments, 65
Design, developing appreciation of, 12
 principles of, 12
 vs. taste, 12
Diana, goddess of the hunt, 81
Dionysius, head of, *47*
Direct approach in art, 133
Di Spirito, Henry, sculpture of, *164*
Doodling, in clay and wax, 68

Drying, of wet clay, 39–40
Duck, modeling of, *20*
Dust, and effect on plastilene, 176

Early American tombstones, *132, 133*
Egypt, pottery and sculpture of, 17
 wax religious figures of, 64
Egyptian carving, *140, 141, 142–143*
18th Dynasty, low-relief carving from, *140*
Elephant, modeling of, *18*
England, wax portrait medallions in, 64
Enlarging, of "Naiad," 174
Enlarging machine, 174
"Escape," *10*
Etruscan statuette, *107*
Exaggeration, to emphasize emotion, 45

Fawn, modeling of, *69–74*
Fingers, as modeling tool, 38–39
Firing, of armature-supported sculpture, 22
 modern, 17
 primitive, 17
 when to do, 40
Fishes, slate by author, *152*
Flagstone, 133
Flight, how to indicate, 81
Florentine School, sculpture of, *99*
Founder, bronze, 121
Foundry, bronze, 119, 121–123
French sand process, 121
Frew, Arnold, jewelry by, *130*

Gas torch, 66
Gates, 121
Gelatin, use in casting, 121
Genesis of a statue, 169–180
Giraffe, slate relief by author, *151*
Girl in a straw hat, by Dorothea Greenbaum, *36*
Glazing, 17
Gorgon, from Greek relief, *49*
Grease, used in plaster mold, 119
Greece, wax figures of early, 64
Greenbaum, Dorothea, sculpture by, *23, 36*
Guerrero, sculpture from, *166*

Han Dynasty, sculpture from, *146–147*
Haniwa, Japanese potters, 17
Hardwood, as base, 122
Hathor Column, *144*
Heads, modeling of, *32–34*
Heat, use of, in wax modeling, 64–65
"Heretic King," sculpture of, *166*
Herons, modeling of, *66–68*
High priestesses, clay figures of, *50*
Hilbert, Georges, sculpture of, *165*
"Homer," *59*
Hot-tool technique, 129

Human figure, articulation of, 45
 Law of Opposition and, 44
 redesigning of, 45
Huysmans, J. K., 83

Ice pick, as used with slate, 136
Ideas for sculpture, ways to develop, 171
Identical twins, Las Remojades style, *55*
Indian brave, modeling of, *34*
Inscribed design, 133
Insects, sculptures by Henry Di Spirito, *164*
Investment, 121
Italian rasp, 136

Jewelry, cast, 123
 facture of wax, 65
Joints, as point for bending, 77

Kiln, defined, 15, 17
 kinds of, 17
 temperature of, 17
Kitchen knife, as modeling tool, 38
Korea, sculpture from, *167*
Krentzin, Earl, demonstration of centrifugal casting by, *125–127*
Kries, Henry, sculpture by, *62*

L'Art Moderne, l'Exposition des Independants, 83
Las Remojades, examples of style, *50–51, 52, 55*
Law of Opposition, 44
"Leapfrog," *100*
Limbs, changing position of, 77
Limestone reliefs, *142–143*
Lost-wax process, 64, 121, 123

Magician, Colima style, *53*
Maillol, Aristide, torso by, *46*
Man's head with crocodile helmet, from Veracruz, *35*
Marble, as base, 122
Marriage couple, example of Nayarit culture, *54*
Matisse, Henri, 12
Mestrovic, Ivan, sculpture by, *59*
Mexico, clay sculpture in, 17
 example of early sculpture from, *53, 54*
 pebble sculpture from, *162, 163*
Mezcala culture, sculpture from, *162, 163, 166*
Michelangelo, 12
Microcrystalline, 64
Middle Ages, attenuated figures of, 45
Milles, Carl, 12
Miniature sculpture, *94, 95*
Mochica, Mexican potters, 17
Modeling, of bear, *21–22*
 clay, in primitive cultures, 17
 as creative outlet, 12
 defined, 15, 134
 of duck, *20*
 of elephant, *18*

Modeling—(*Continued*)
 of heads, *32–34*
 of mouse, *19*
 of prophet, *24–27*
 as release from tensions, 12
 self-supported (unsupported) wet-clay, 22
 of snail, *16*
 of snake, *14–15*
 tools for, *38–39*
 of torso, *39–45*
Modeling clay, care of, 39–40
Modeling tools, 38–39, *182*
Modern Art Foundry, 178
Mold, plaster, 119–120
Monet, Claude, 12
Monk, sculpture of, *148*
Mother and child, by the author, *56*
Motion, how to create impression of, 81
"Mounted Indian," *101*
Mouse, modeling of, *19*

"Naiad," *118, 180*
 armature for full-scale model, 174
 armature for scale model, 171–172
 casting into plaster of Paris, 177
 chasing of, 179
 choice of medium for, 173–174
 developing ideas for, 171
 developing planes and textures of, 172
 enlargement of, 174
 genesis of, 170–180
 installation of, 179–180
 patination of, 179
 remodeling of, 174, 176
 scale model of, 170–171
 wax reproduction of, 179
Nail, as used with slate, 136
Nayarit culture, sculpture from, *54*
Nefertiti, 45
Nigeria, sculpture from, *104, 105*
Nile Delta, carving from, *144*
"Noah's Ark," *153*
Noteriani, Phillip, sculpture of, *106*
Nude, sculpture of, *138–139*
 slate by author, *155*
Nymph, modeling of, *75–80*

"Old Courtesan, The," *102, 103*
Omphale, *99*
Orange stick, as modeling tool, 38
Oven, in casting, 122
"Ox and Boy," *97*

Pachyderm, from Korea, *167*
 sculpture of, *134–137*
Panama, pendant from, *107*
Patina, 121
Patination, 123
 of "Naiad," 179
Patine, 121
Pebble sculpture, 159–167
Pebbles, 161

Peccary, by Georges Hilbert, *165*
Pecking hen, slate by author, *158*
Pencil, as modeling tool, 38
Planes and textures, 172
Plaster of Paris, bat of, 40
 casting of "Naiad" into, 177
 drying of, 172
 use of, in casting, 119
Plastic film, in keeping clay pliable, 39
Plasticine (see *Plastilene*)
Plastilene, 14, 38
 defined, 38
 vs. clay, 38, 173–174
 when preferred, 38
"Point of Decision," *60*
Points of reference, 174
Portfolio of Degas waxes, *82–93*
Portrait medallions, 64
Post-Classic period, clay sculpture in, 17
Pottery, of early cultures, 17
Pre-Columbian, examples of sculpture, *50–51, 162, 163*
 Mexican potters, 17
Primitive art, *104, 105*
Primitive cultures, clay sculpture in, 17
 firing in, 17
 pottery of, 17
 three-dimensional expression in, 11
Prize fighter, modeling of, *34*
Prophet, modeling of, *24–27*

Rasps, *182*
 Italian, 136
Redesigning of human figure, 45
Reducing, of sculpture, 174
Renaissance, wax models of, 64
Renaissance Italy, 121
Rifflers, 136, *183*
Rodin, Auguste, 36, 41, 121
 sculpture by, *37, 102, 103*
Roman joints, 177, 179
Roth, Richard, architect, 180
Rox, Henry, sculpture by, *58*
Rudier, 121
Rudin, Paul, assistant to author, 176, 177
Russo, Vincent, caster, 172, 173

Sakkara, low-relief carving from, *141*
Sarcophagus, carving on, *141*
Scale model, making of, 170–171
Screw driver, as used with slate, 136
Scriber, 136
Sculptors' suppliers, 184–187
Sculptors' tools, *182–183*
Sculpture in ancient civilizations, 11
 defined, 134
 as means of communication, 11
 miniature, *94, 95*

Sculpture in ancient civilizations
 —(*Continued*)
 misconceptions about, 11
 subminiature, *95*
Sculpture-in-the-round, 161
Sculpturing, as creative outlet, 12
 defined, 15
 develops appreciation of design, 12
 effect on sculptor, 11
 as esthetic experience, 11
 gratification obtained from, 11
Seal, slate by author, *156*
Self-supporting wet-clay modeling, 22
"Shark Diver," *61*
Shims, 119, 177
"Short" clay, 39
Shrinkage, of clay, 14
"Silky" clay, 39
Silver clown bottle, casting of, *125–127*
Silver soldering, 66
Skeleton, 44
Slabs, of clay, 17
Slate, 131–158
 advantages of, 133–134
 colors of, 133
 defined, 133
 as direct approach in art, 133
 for inscribed designing, 133
 merits of, as sculptural medium, 133
 tools for, 136
 use of color with, 134
 vs. clay and wax, 134
 where obtained, 133
 workability of, 133
Sleeping youth, Roman terra cotta, *48*
Slip, 14
Smiling boy, from Veracruz, *36*
Snail, modeling of, *16*
Snake, modeling of, *14–15*
Soap, used in plaster mold, 119
Spoon birds, modeling of, *123–124*
Spring, John, founder, 178
Sprue, 121
Statue, genesis of a, 169–180
Stele, Chinese, *145*
Stone, as modeling tool, 38
 as permanent medium, 41
Subminiature sculpture, *95*
Suppliers, sculptors', 184–187
Swarz, Sahl, sculpture of, *96, 97*
Swinging girl, Las Remojadas style, *52*

Taste, 12
Textures and planes, 172
Thickness, of statue, 40
30th Dynasty, deep-relief carving from, *144*
 low-relief carving from, *141*
Three-dimensional expression, 11, 180

Tie rods, bronze, 122
Titian, 12
Tlatilco culture, clay pot from, *23*
Tombstones, early American, *132, 133*
Tools, clay modeling, *182*
 for modeling, 38–39
 sculptors', *182–183*
 for slate, 136
Toothed chisel, 136
Torso, modeling of, *39–45*
Transient media, 41
"Trojan Horse," *112*
Trojan War, scene from, *49*
Troubetzkoy, Prince Paul, sculpture of, *108*

"Unicyclists," *113*
Unsupported wet-clay modeling, 22

Vents, 122
Veracruz, Mexico, 36
 examples of early sculpture from, *50–51, 52, 55*
 head from, *35*

Waste mold, 120
Water buffalo, slate by author, *155*
Wax, 63–116
 advantages of, 64, 81
 casting into metal, 65–66
 creating compositions in, 81
 disadvantages of using heat with, 65
 early modeling in, 64
 permanence of, 64
 preparation of, 65
 scope of, in modeling, 64
 techniques in modeling with, 65
 as transient medium, 41
 use of heat with, 64
Wax figures, changing position of, 77
 of Degas, *82–93*
 of Egypt, 64
 of Greece, 64
 of Renaissance, 64
Wax sketch, as scale model, 65–66
Weathering, 122
Wedging, 15
Wet clay, 39–40
Wet-clay modeling, self-supporting (unsupported), 22
Whale, slate by author, *154*
Wheel, invention of, effect on pottery making, 17
Wheel throwing, 17
Wires, 125
"Woman of India," *150*

"Yoke, The," *58*
Young girl and gazelle, by Henri Bouchard, *98*